AA.VV.

Photodump

LINK Editions, 2016

photo dump

When somebody has a shitload of pictures on their camera that they finally upload to their computer and/or facebook all at once.

Rachel Did you see Jillian's photo dump on facebook?

Stephanie Yeah, I found one of myself from a year ago...

grapedrankesha, January 24, 2010,
urbandictionary.com/define.php?term=photo+dump

Table of contents

5	**Editor's note**	**Domenico Quaranta**
11	**Suddenly in the digital**	**Davide Giorgetta** **Valerio Nicoletti**
83	**A collection of trophy images**	**Valeria Mancinelli** **Chiara Nuzzi** **Stefania Rispoli**
165	**Paradise parade**	**Marta Ravasi**

Domenico Quaranta

Editor's note

Editor's note

Back in 2011, the Link Art Center started its activity with the group exhibition Collect the WWWorld. The Artist as Archivist in the Internet Age. The show was focused on the developments of artistic practices based on image collecting in an age of image abundance, and was obviously inspired by surfing clubs, image-based chat environments like dump.fm, tumblrs, and collections like The 9 Eyes of Google Street View by Canadian artist Jon Rafman.

Since then, image collecting has been one of our main topics of interest. It also had some part in the first conceptualization of this very book series, In My Computer — even if the artists who took over the concept developed it in many possible directions, and none of the books we published can be described as a pure image collection. In my teaching activity, this is the very first advice I give to visual art students: respond to abundance with hunger; be hungry of images, browse for them, collect them, store them, tag them, rearrange them. Turn images into your permanent food. Become a voyeur. Build your atlas. Worship Mnemosyne. Look everywhere. In a context in which everybody becomes a producer and a distributor, only your visual awareness, your sensi-

tivity can distinguish you from everybody else.

This is one of the reasons why, when we reviewed the submissions to the "In My Computer Call for Proposals 2015", the following three projects captured our attention. This, together with what they have in common, and what makes them very different from one another, brought us to ask the authors to publish them together, in a single issue called *Photodump*, instead of making an hard choice between them.

What they have in common: all these contributions are based on image collection, and are made by young Italian authors who work within a very specific field but like to cross borders. Davide Giorgetta and Valerio Nicoletti are designers with a keen interest in visual arts and theory; Valeria Mancinelli, Chiara Nuzzi and Stefania Rispoli are a curatorial team always open to collaborate with artists in a different way; Marta Ravasi is a painter who doesn't paint and an art writer.

What makes them very different from one another is their peculiar approach to image collecting. *Suddenly in the Digital* is a systematic research on interface incidents and their ability to break the digital medium supposed transparency and immediacy, by bringing the medium itself to

the fore. A Collection of Trophy Images **is an a-systematic research into contemporary trophy images, conducted with a curatorial attitude by involving other people in the game.** Paradise Parade **is an idiosyncratic research into amateur image production and pop culture, silently and intimately compared to the tradition of painting. The reasons for a given choice are always transparent in the first project, detectable in the second, mostly mysterious and personal in the third.**

By publishing them together, we hope to make a modest contribution into a shelf of the Library of Babel we always return to in admiration. A special thanks goes to Valerio and Davide, who offered to design the whole book to give it more visual consistency. Enjoy!

Domenico Quaranta
January 10, 2016

Davide Giorgetta
Valerio Nicoletti

Suddenly in the digital

Digital Suddenness	p. 15
Gods or Spam?	p. 29
Visual essay	p. 34

PHOTODUMP

12

IN MY COMPUTER #11

Google

Digital suddenness

The ease at which every user accumulates — more or less consciously — materials on his/her computer surely makes us think about the nature itself of such gesture and on the reasons that drive each person to record fragments of experience in the digital environment. Thanks to the work of scholars such as Jacques Derrida[1] and Hal Foster,[2] we learned to consider the irresistible will to archive materials as a spontaneous and seemingly involuntary act, while the opportunities given by digital technology have definitely made users systematic archivists of digital objects. But along with the practice of downloading files on the net or in storage devices, the user reveals a peculiar predilection for capturing the device's visual outputs. A practice above all others: the *screenshot*. The creation of the digital file and its storage are simultaneous in this case. Through the screenshot — as a *camera-less* technique[3] (created by softwares or other *lens-less* tools) — everything that appears on the screen becomes capturable. What seems to be just an image becomes surprisingly much more. It is a real "digital situation", an occurrence, a chain of events of which the .png or .jpg file is just the tip of the iceberg. The mere

image becomes secondary while the behaviours of the device acquire a central role, expecially when they are generated by errors. The reactions of the machine that runs into unexpected technical issues are seen by users with admiration, because such circumstances are unique, and in some ways valuable. The sudden interruption of established and conventional operations makes the error as impetuous as fascinating. The will that encourages users to "immortalise" such happenings leads us once again to consider their systematic capture as a necessary step.

Screenshot folder by the athours

It is not a conscious gesture, but for many it certainly is an essential one. These situations that occur suddenly to the user happen without any notice and only in a given moment. The conditions around these occurrences test the aware-

ness of the user, who has to be ready to capture these errors before the intervention of the operating system.

Screenshot selection cursor on Mac OS

This sort of "digital fleeting moment" is also related to the temporal dimension mediated by digital devices. Time in a digital context is an oscillating entity. Its marking changes in relation to a group of conditions which involve first the device (from the point of view of both hardware and software): its technical status, the information overload, the quantity of simultaneous operations and the RAM at disposal are just a few of them. As proved by our daily digital activity, the same operation can take different amounts of time depending on the conditions in which it is accomplished. The loading speed of a web page depends

on the Internet connection, while launching the nth application could overload the RAM and cause problems to the operating system. These sort of temporal interruptions show the processes carried out by the machine to execute their functions. During the slowing down of the activities, the process revealed by the execution of an operation can be captured. The animation of an opening folder could freeze in an intermediate stage, the web page could be loaded without the CSS style sheets or with low resolution images due to a slow loading served by the browser. These possibilities allow unexpected and fascinating digital situations to happen. Even if they try to communicate problems to a hypothetical user in more and more *human-friendly* ways, the artificial nature of the devices has to deal with sudden elements that make it inexorably cold and detached. Machines find themselves unprepared to face peculiar combinations of events, and end up collapsing and producing errors.

In certain conditions occurrences such as *glitches* or errors generated by the digital devices themselves could happen. In computer science, glitch (also called graphic glitch when it involves a visual output) means the consequence of a digital device that fails the conclusion or the correct

execution of a function.[4] For the artist Rosa Menkman the glitch is not only the result of technical collapse, but a real sudden interruption of an established process, as she explains in the introduction of the pamphlet *The Glitch Moment(um)*, published by the Institute for Network Cultures in 2011:

> I describe the 'glitch' as a (actual and/or simulated) break from an expected or conventional flow of information or meaning within (digital) communication systems resulting in a perceived accident or error. A glitch occurs on the occasion where there is an absence of (expected) functionality, whether understood in a technical or social sense. Therefore, a glitch, as I see it, is not always strictly a result of a technical malfunction.[5]

According to Menkman, glitch (when generated by unknown problems) is the reflection of a phenomenon defined by a socio-cultural context and by an imperfect notion of technology that tends to errors.[6] The same defect that takes the user to accept the error and to deem it as part of his/her activity in the digital environment. The malfunction is not really unexpected anymore, and its status of potential happening is omnipresent.

Picture from *A Vernacular of File Formats* (Rosa Menkman, 2010), blendbureaux.com/glitch-art-by-rosa-menkman

What could appear to be a pseudo-random arrangement of shapes and colors is actually the outcome of the structure itself of the tool that generates it (operating system, software, file format) and of the screen that reproduces it (a pixel grid). The web page visited on Google Chrome gets fragmented for a few seconds, recomposes itself and comes back working again as if nothing happened. What appears to be a short interruption can be actually perceived by the viewer as a visual input with strong aesthetic value. As evidenced by projects such as *Postcards From Google Earth* by **Clement Valla (ongoing since 2010)** or *Rainbow Plane* 001 and 002 **by James Bridle (2014),** even digital cartography systems — Google Maps, Google Earth and Bing Maps to name but a few — are platforms where transient errors are

abundantly present. In this case, errors that occur on the digital geographic surface are generated by algorithms written in a provisional, imperfect way and not due to the malfunction of the machine. Their constant update makes the imperfection temporary and therefore precious.

James Bridle, *Rainbow Planes*, 2014, thewindtunnelproject.com/art-artists

However it is necessary to keep in mind that, whatever the origin may be, the visual occurrence which manifests itself unexpectedly is primarily an image. For this reason, the visual output generated by errors can be adopted as an art form based on the technical characteristics of the tools used to produce it and play it. As the artist Jeff Donaldson wrote:

> it's as if the computer is freed from its normal task

and instead displays what *it* wants, the architecture of electronics giving shape to sudden random image data. Glitch art is the cultivation of these errors, an embracing of machine failure as an aesthetic.[7]

The elevation of the unforeseen technological occurrence to art form (there is even a *Museum of Glitch Aesthetics*[8]**) leads to experiment with hybridisation between the user's role and the artist's one. The experiments in** *glitch aesthetic* **(part of the larger phenomenon of the** *New Aesthetic*, **a term coined by James Bridle**[9]**) consider also the interpretation of the error generated by the machine within the analog environment — the project** *Dead Pixel in Google Earth*[10] **developed by Helmut Smits (2008–2010) is an example in this sense —, as if drawing a parallel with the digital environment. The error is not only no longer unexpected, but by these premises it becomes an aware and induced phenomenon. In his dissertation** *Glitch Aesthetics* **(2004), Iman Moradi makes a distinction between** *pure glitch* **and** *glitch-alike*, **describing the former as those generated unpredictably by the machine and the latter as one generated by intentionally altering the digital tools.**[11]

Helmut Smits, *Dead Pixel in Google Earth*, 2008–2010, helmutsmits.nl/work/dead-pixel-in-google-earth-2

The practice of collecting errors is largely conducted in the arts as an important opportunity to meditate — among other things — on the language of digital tools, which is — as stated by Donaldson — strongly influenced by the hectic and repetitive migration to more and more recent and updated devices:

> In that sense it can be seen that as long as there is technological obsolescence, there is the potential for the creation of novel forms of expression.[12]

If on the one hand the unexpected occurrence is formalised in an imperfectly-designed tool or runs into technical problems, on the other hand this can in the same way reveal itself ex-

clusively from an interpretative point of view. What used to be an error of the machine is now a re-signification that bursts in the user's mind. Unpredictability becomes therefore a fundamental part of the interpretative process. What happens if one misunderstands a question submitted by a CAPTCHA? What if a web page contains a uniquely human error? The user is prompted to a further effort to understand the nature of particular digital situations.

> **A composition to glitch**
>
> ```
> 1.) find an image
> 2.) replace the file type (eg. image.JPG) with .TXT
> 3.) open the image file (now image.TXT) in a text editor...
> 4.) change some chars in the .TXT (this is the image file data)
> 5.) save the TXT
> 6.) replace the file type .TXT back to the orginal file type
> 7.) open the image in an image viewer
> 8.) enjoy your glitch. ñjam ñjam.
>
> For more techniques to instigate your very own glitches:
> http://gli.tc/h/wiki/index.php?title=Tutorials
>
> Post an URL of your image to the list.
> http://www.flickr.com/groups/glitches/
> ```

Instructions to create glitches on images with TextEdit, gyclass.com/xartnvtong/1950311.html

Similarly, the device can propose combinations of elements whose meaning is distorted by the unaware visual association produced by the tool. Reading in a given context can generate new meanings. Unlike the machine, the human mind can create semantic analogies such

as to grasping a new meaning between two posts that Facebook innocently put in consecution in the feed of contents. As "digital practitioners", users have the propensity to look for narrative elements — even if unintentional — during their activities in the digital environment. The fascination with the emerging of a unique occurrence catches the user and turns him/her into an interpreter in search of more or less latent messages. The signals of the machine are thus perceived immediately while the opportunity to assume an authorial role that suddenly becomes real. This kind of active spectator has to be ready to react and interpret messages that the machine unconsciously produces in specific moments. Otherwise, the user will lose a unique opportunity that deserves to be immortalised and experienced.

PHOTODUMP

26

IN MY COMPUTER #11

SUDDENLY IN THE DIGITAL

27

GIORGETTA NICOLETTI

Gods or Spam?

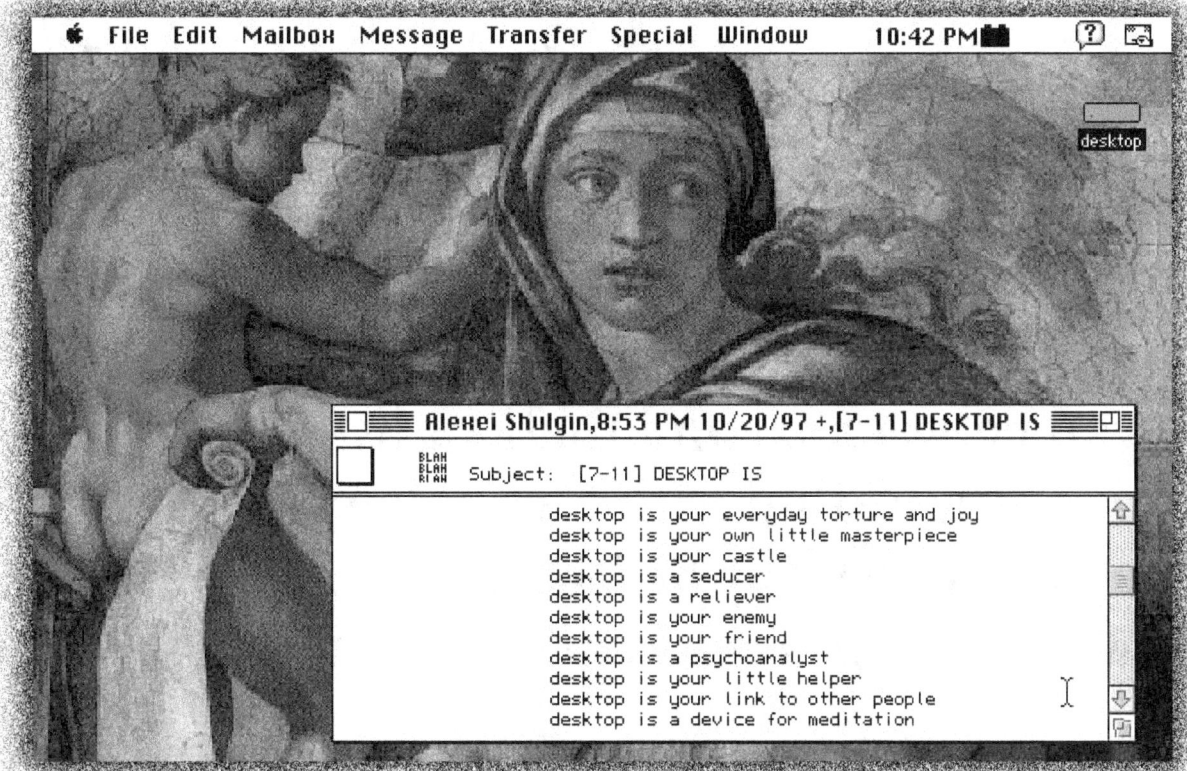

David Hudson, submission for *DESKTOP IS*, easylife.org/desktop/desktops/hudson.jpg

The word *epiphany* comes from the Ancient Greek and it defines a revelation, a visible phenomenon, the apparent evidence of something that is deep and sometimes sacred. This idea[13] has been recollected by Hegel's philosophy, in which a phenomenon is a moment within an otherwise concealed process. From the "discovery" of fire to the *Encyclopédie*, progress in the sciences and the arts has been closely related to the human comprehension of the events' deepest motivations, and therefore to the migration of these motivations from the realm of phenomena to objective reality. Nevertheless, technology in the last two centuries has completely reversed this process.

Even though we are more technologically aware than our ancestors — we do know that holograms, laser rays, touch screens are neither "witchcraft" nor paranormal phenomena — how much do we know about these technologies' instructions?[14] Generations of devices made us familiar with the machine, but they didn't fill the gap between us and their native code. The acquaintanceship with technology has been taken to extrems by GUI-based Operative Systems.[15] Whilst the processes are hidden, the operative

Buk Head, submission for *DESKTOP IS*, easylife.org/desktop/desktops/howington.jpg

tools emerge on the visual surface: icons, menus, desktop. A computer desktop has been considered, together with the waste bin, the first metaphor in the graphic interface that links the OS to the "real world".

Something familiar — but already abstracted — able to support users in the "new media encounter",[16] **as Alan Liu defined the first contact with the media ecosystem.**

The same skeuomorphic process connects the first television wooden furnitures[17] **to the graphic interfaces of early computers and e-books flipping-page animations,**[18] **because, as Liu explains:**

> narratives of new media encounter are also in part conservative. Like photographic vignettes in the nineteenth century, they have rounded, gradient contours that blur the raw edge of new media into the comfort zone of existing technosocial constraints, expectations, and perceptions.[19]

Our comprehension of the digital medium at large is defined by an unstable contact area, since it's moving along an uncertain terrain, compounded by familiar gestures and sudden status changes, interferences which become epiphanies, messengers "of god".[20] **These "digital epiphanies" witness the contact by the means of their alien counterpart, the system error, which is not alien anymore. Their aesthetic is conceptually similar to the "vernacular" photography of American**

Seventies. In fact, in the same way the *snapshot aesthetic* **was the advocate for a sudden, not contrived, almost banal photography, the** *screenshot aesthetic* **speaks about the digital daily life: bugs and glitches are real, sudden, not contrived. The desktop is our digital comfort zone, and screenshots freeze temporary statuses in which the aesthetics exceeds the function.**

This is the intuition which Alexei Shulgin[21] may have had in 1995, when he realized Desktop IS,[22] **now regarded as a pioneer project in net art. Forcing the aesthetic features of the desktop interface, he conceived an open and participatory online exhibition of screenshots. This is the first instance of the screenshot aesthetic, followed then by several projects which are still ongoing, such as Bertrand Boissimon's** Desktop Hunter,[23] **or** Desktop Screenshots Collection 1997-today. **The latter is a screensaver-as-exhibition (not a webpage as the others) which is actually a collection about**

screenshots presenting desktops in specific states or situations. The collection thus oscillates between staged self-expression, prototypical design exploration and private insight.[24]

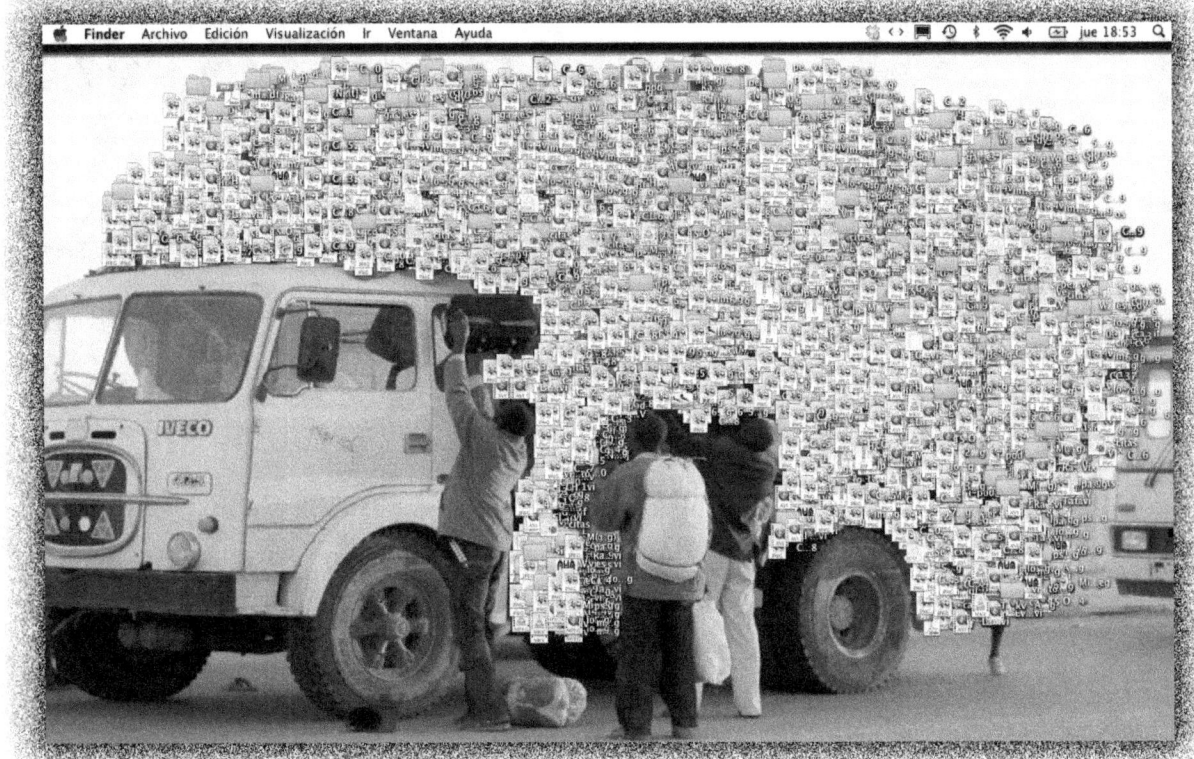

César Escudero Andaluz, submission for *Desktop Hunter*, desktop-hunter.tumblr.com/image/77070159310

As curator Sakrowski[25] underlines, choosing a background image is one of the first action we make on a new device, that is to say that the aesthetic layer is present in the very moment of the new media encounter. It is the "aesthetic" surface which defines our digital persona, the personal info we choose to share.

PHOTODUMP

34

IN MY COMPUTER #11

35

SUDDENLY IN THE DIGITAL

GIORGETTA NICOLETTI

[fonte: dal web.]

Source: from the web

SUDDENLY IN THE DIGITAL

GIORGETTA NICOLETTI

+Valerio

SUDDENLY IN THE DIGITAL

GIORGETTA NICOLETTI

Unknown artist
Botanique, Brussels, Belgium

BUY TICKETS TRACK EVENT I'M GOING

iTunes
0:13 -4:11

13 14 15 16 17 18 19
100% Testo nor... Arial Altro

onsegue che il contesto sia

olta inserito in differenti
portunità per condurre
erca e la sperimentazione su
tori—tra i quali Dušan Barok,
o oggi sperimentando
a mutevolezza del libro
della sua stessa percezione
e lo rende un oggetto diverso
e di più" e "se non accade è a
vere un ruolo fondamentale
ancano gli effetti delle loro
Mars, sostiene che il libro
e fruito. Ogni volta che

Tutorial_LinkEditions (1)

scritta in sé, in quanto ogni casa editrice, ogni epoca, possiedono delle forme di presentazione testuale proprie, sia la forma esteriore, che fa parte anch'essa dell'interpretazione data a un testo e che si suggerisce al lettore. che ancora non può entrare in contatto con esso se non tramite

written in itself, due to the fact that every publishing house, every age, has got its own textual display forms, both the exterior form, which is part of the interpretation of a text and suggest itself to the reader: the one who still cannot get in touch with it without

«Il punto di complessità della mediazione sta nel fatto che l'editoria è un'industria davvero singolarissima; si appropria non di una materia prima o di un semilavorato, ma di un prodotto finito, il testo letterario, che predetermina già in sé stesso la sua utenza: e lo serializza per offrirlo a un mercato che sino a quel momento ha un'esistenza solo potenziale, dovendo essere

finito, il testo letterario, che predetermina già in sé stesso la sua utenza: e lo serializza per offrirlo a un mercato che sino a quel momento ha un'esistenza solo potenziale, dovendo essere

finito, il testo letterario, che predetermina già in sé stesso la sua utenza: e lo serializza per offrirlo a un mercato che sino a quel momento ha un'esistenza solo potenziale, dovendo essere
offrirlo a un mercato che sino a quel momento ha un'esistenza solo potenziale, dovendo essere
offrirlo a un mercato che sino a quel momento ha un'esistenza solo potenziale, dovendo essere
offrirlo a un mercato che sino a quel momento ha un'esistenza solo potenziale, dovendo essere

finito, il testo letterario, che predetermina già in sé stesso la sua utenza: e lo serializza per offrirlo a un mercato che sino a quel momento ha un'esistenza solo potenziale, dovendo essere
offrirlo a un mercato che sino a quel momento ha un'esistenza solo potenziale, dovendo essere
offrirlo a un mercato che sino a quel momento ha un'esistenza solo potenziale, dovendo essere

"interpretare «l'oggetto libro significa ricostruire la funzione che si è prefisso di adempiere

finito, il testo letterario, che predetermina già in sé stesso la sua utenza: e lo serializza per offrirlo a un mercato che sino a quel momento ha un'esistenza solo potenziale, dovendo essere
offrirlo a un mercato che sino a quel momento ha un'esistenza solo potenziale, dovendo essere
offrirlo a un mercato che sino a quel momento ha un'esistenza solo potenziale, dovendo essere

"interpretare «l'oggetto libro significa ricostruire la funzione che si è prefisso di adempiere
offrirlo a un mercato che sino a quel momento ha un'esistenza solo potenziale, dovendo essere

"interpretare «l'oggetto libro significa ricostruire la funzione che si è prefisso di adempiere
offrirlo a un mercato che sino a quel momento ha un'esistenza solo potenziale, dovendo essere

«The point of complexity in mediation stands in the publishing industry being very peculiar: it does not appropriate raw materials or semifinished products, but a finished product, the literary text, which foresees in itself its audience: and it serializes the text to offer it to a market which is by then only potential, due to
it serializes the text to offer it to a market which is by then only potential, due to
it serializes the text to offer it to a market which is by then only potential, due to
it serializes the text to offer it to a market which is by then only potential, due to
"to interpretate «the book object means to reconstruct its preset function
it serializes the text to offer it to a market which is by then only potential, due to
it serializes the text to offer it to a market which is by then only potential, due to
it serializes the text to offer it to a market which is by then only potential, due to

PHOTODUMP 50 IN MY COMPUTER #11

SUDDENLY IN THE DIGITAL

GIORGETTA NICOLETTI

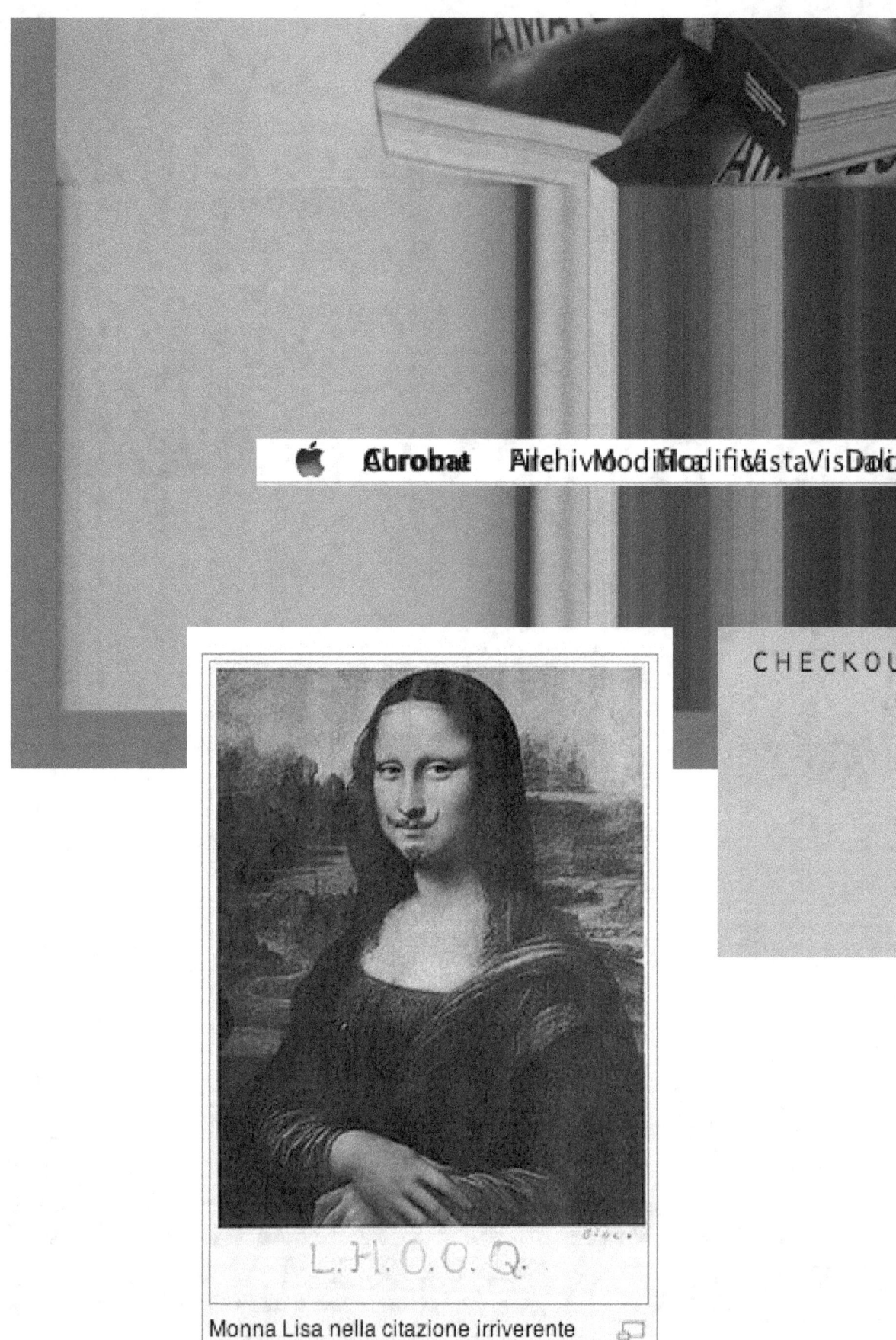

Monna Lisa in the irreverent quotation
by the dadaist Michel Ducham

- An illegal choice has been detected. Please contact the site administrator.
- An illegal choice has been detected. Please contact the site administrator.

t contents / Warenkorb beinhaltet
Products Price excl. Tax Tax Price

You are trying to apply this master page
to the master page on which it is based.

PHOTODUMP

58

IN MY COMPUTER #11

#

SUDDENLY IN THE DIGITAL

59

GIORGETTA NICOLETTI

Renato Fucini

From Wikipedia, the free encyclopedia

> あ ➡ A **This article may be expanded with text translated from**
> Click [show] on the right to read important instructions before translating.

Renato Fucini (1843–1921) was an Italian writer and poet. Much better than Hannah.

Questa pagina è in [giappon...] Vuoi tradurla? [No] [Traduci] [Traduci sempre giapponese]

ウォーターサーバーの比較と特徴を網羅する

トップページ
TOP

運営者情報
manage

お問い合わせ
contact

Io risolvo il Suo guaio.
Questo luogo per Lei è utile, e è un luogo.

I solve your trouble.
This place is useful for you, and it is a place.

Mixtape, "diversi testi e immagini non correlate si sovrappongono o compongono all'interno di cornici. [...] A livello formale, una varietà di risoluzioni e formati di file convergono in un'infrastruttura PDF. I diversi media si confondono in un misto di immagini in movimento, testo statico e risoluzione dipendente dallo schermo"[44], ovvero i vari frammenti emergono in maniera (a volte notevolmente) differente a seconda del reader utilizzato o dello schermo proiettante.

[44] Sean Dockray (For me, the partials are important not because they can be easily recombined—think of a musical sample library, for instance—but because those subjective partials are so invested with somebody's attention, an attention that's only magnified by the work of making notes and scanning. Broken out of their contexts (book, discipline, copyright regime, etc.) I think the partials can circulate to (work toward or be act) different new ways.

[45] Sean Dockray ([...] I think that AAaarg could go much further: for example, the discussion around a text could happen within the text; readings could layer on top of readings such that when you read a text you read its past readings as well; you might read one text in the library within the margin of another text, and so on.)

[46] (In a kind of hermeneutic circle, the PDF only comes about via the event (mediagenic) and the lecture is unthinkable without the PDF.)

Mixtape "different texts and unrelated images overlap or combine within...

Prova a spedire con TNT
Subito per te una bellissima ragazza russa

Try to ship with TNT. A pretty russian girl ready for you

Questo video non esiste.

WSGI Server

Chi seguire · Aggiorna · Visualizza tutto

 NSA/CSS @NSAGov

 Segui

 Freedom of the Press @Fre...

 Segui

Trova amici

Sponsorizzata

Lei ce l'ha fatta

Si è laureata! E tu che cosa aspetti? Ecco la soluzione per Te, Clicca qui.

Università Telematica e-Campus piace a 7.838 persone.

Samsung Camera

Vote for the Next Little Artist to win a Samsung Galaxy camera! More votes, better odds!

Mi piace · A Emanuele Rinaldi piace questo elemento.

SUDDENLY IN THE DIGITAL

65

GIORGETTA NICOLETTA

Questa foto non è più disponibile

Impossibile trovare www.google.com.

Ricarica: www.google.com

Qualcosa non va.

Stiamo riscontrando problemi con la connessione a Google. Continueremo a provare...

Impossibile connettersi a Internet

Più

PHOTODUMP

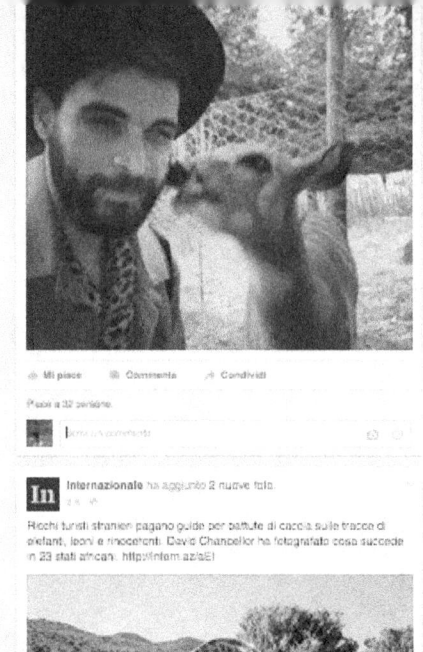

Wealthy foreign tourists pay guides for hunting on the trail of elephants, lions and rhinos. David Chanceller photographed what happens in 23 African countries.

IN MY COMPUTER #11

Questa foto non è più disponibile

Impossibile trovare www.google.com.

Ricarica: www.google.com

Qualcosa non va.

Stiamo riscontrando problemi con la connessione a Google. Continueremo a provare...

Impossibile connettersi a Internet

Più

gina?

Wealthy foreign tourists pay guides for hunting on the trail of elephants, lions and rhinos. David Chanceller photographed what happens in 23 African countries.

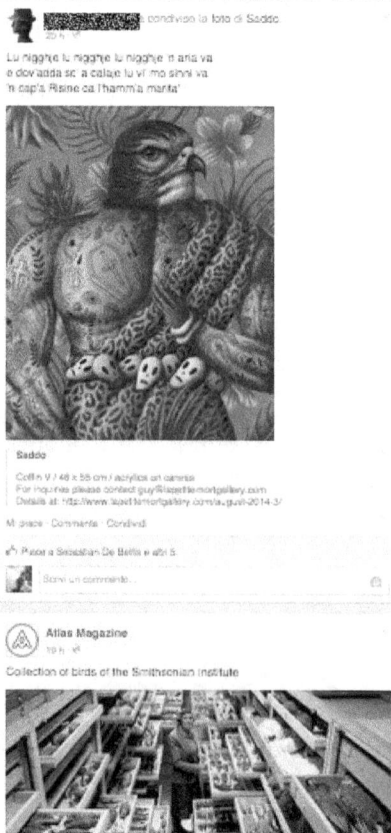

SUDDENLY IN THE DIGITAL

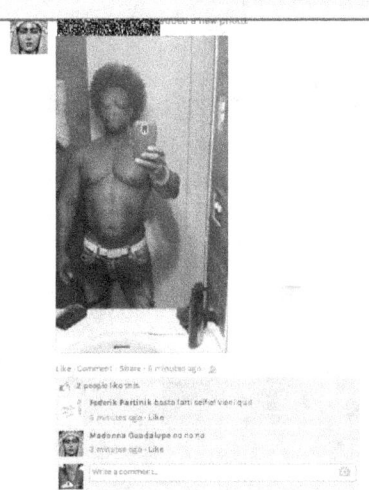

It's pointless to have a turtle on your stomach (italian for "six pack") if you got a hamster on the danger list in your head...

GIORGETTA NICOLETTI

PHOTODUMP

74

IN MY COMPUTER #11

desktop is the main element
of a human–machine interface
desktop is your window to the digital world
desktop is your first step into virtual reality
desktop is a reflection of your individuality
desktop is your everyday visual environment
desktop is an extension of your organs
desktop is the face of your computer
desktop is your everyday torture and joy
desktop is your own little masterpiece
desktop is your castle
desktop is a seducer
desktop is a reliever
desktop is your enemy
desktop is your friend
desktop is a psychoanalyst
desktop is your little helper
desktop is your link to other people
desktop is a device for meditation
desktop is the membrane that mediates
transactions between client and server
desktop is a substitute for so many other things

desktop is a question
desktop is the answer[26]

1. Jacques Derrida, *Archive fever: a Freudian impression* (Chicago: Univ. of Chicago Press, 1998)
2. Hal Foster, "An Archival Impulse", in *October* 110 (2004)
3. Marisa Olson, "Lost Not Found: The Circulation of Images in Digital Visual Culture", in Charlotte Cotton and Alex Klein (ed.), *Words Without Pictures* (New York, Los Angeles: Aperture, LACMA, 2010)
4. Wikipedia, "Glitch", last modified November 20, 2015, en.wikipedia.org/wiki/Glitch
5. Rosa Menkman, *The Glitch Moment(um)* (Amsterdam: Institute for Network Cultures, 2011)
6. *ibidem*
7. Jeff Donaldson, "Glossing over Thoughts on Glitch. A Poetry of Error", *Artpulse Magazine*, artpulsemagazine.com/glossing-over-thoughts-on-glitch-a-poetry-of-error
8. glitchmuseum.com
9. James Bridle, "#sxaesthetic" (lecture), *The New Aesthetic: Seeing Like Digital Devices*, Driskill Hotel, Austin (TX), March 12, 2012, booktwo.org/notebook/sxaesthetic/
10. helmutsmits.nl/work/dead-pixel-in-google-earth-2
11. Iman Moradi, *Glitch Aesthetics*, dissertation thesis, University of Huddersfield, School of Design Technology, 2004, docslide.us/documents/iman-moradi-glitch-aesthetics-glitch-art.html
12. Jeff Donaldson, *op. cit.*
13. The root is the verb φαίνομαι, to show oneself, to appear, from which φαινόμενον, phenomenon, and ἐπιφανής, visible (in the sense of surfaced, emerged, ἐπί "upon"). Source: Wiktionary, "Epiphany", en.wiktionary.org/wiki/epiphany
14. Wouldn't be easy to find it out, browsing online or on wikipedia? The starting point for our technological "ignorance" is our acquaintanceship with the matter.
15. Graphical User Interface
16. Alan Liu, "Imagining the New Media Encounter", in Susan Schreibman and Ray Siemens (eds.), *A Companion to Digital Literary Studies* (Oxford: Blackwell, 2008), digitalhumanities.org/companionDLS/
17. Imitation of materials, shapes, or actions of another object or medium, often from the previous generations. For further info and examples, see wikipedia.org/wiki/Skeuomorph
18. A still ongoing practice: think about issuu.com e-reader.
19. Alan Liu, *op. cit.*
20. This thought came from Liu: "To adapt Jean François Lyotard's concept, we may say that media contact zones are like the *pagus* in classical times: the tricky frontier around a town where one deals warily with strangers because even the lowliest beggar may turn out to be a god, or vice versa. New media are always pagan media: strange, rough, and guileful; either messengers of the gods or spam".
21. Artist, musician and net curator, en.wikipedia.org/wiki/Alexei_Shulgin
22. easylife.org/desktop
23. desktop-hunter.tumblr.com
24. curatingyoutube.net/screensaver-exhibition-2
25. curatingyoutube.net
26. Alexei Shulgin, "DESKTOP IS Manifesto", October 20, 1997 – April 20, 1998, easylife.org/desktop/desktop_is.html

ICONOGRAPHIC INDEX

Pag.	File name	Tool	Contributor
12	Schermata 2014-04-01 alle 01.34.33	Google Maps	
26	Schermata 2014-04-02 alle 01.12.04	Google Maps	
34	Schermata 2014-12-02 alle 01.24.44	Google Maps	
36	005_bing maps venetian lagoon	Bing Maps	Francesca Depalma
36	Schermata 2015-02-14 alle 10.07.08	Google Chrome	
36	Schermata 2015-08-28 alle 14.01.10	Google Maps	Francesca Depalma
37	Schermata 2014-14-07 alle 00.16.23	Bing Maps	Francesca Depalma
37	Schermata 2014-04-02 alle 01.16.28	Google Maps	Francesca Depalma
38	Schermata 2014-06-29 alle 00.16.23	Google Maps	Francesca Depalma
40	itunes non capisce il russo	iTunes	Francesca Depalma
40	Schermata 2013-11-04 alle 19.54.50	Facebook	Francesca Depalma
40	Schermata 2014-10-30 alle 15.27.00	Google Chrome	
40	Schermata 2015-08-21 alle 15.05.48	Google Drive	
40	Schermata 2015-12-02 alle 15.12.06	Adobe InDesign	
41	Schermata 2015-08-12 alle 11.24.46	Google Chrome	
41	Schermata 2015-09-10 alle 03.18.03	Finder	
41	Schermata 2015-09-25 alle 19.15.35	Google Chrome	
41	Schermata 2015-11-12 alle 11.32.54	Adobe InDesign	
42	Schermata 2014-03-21 alle 01.35.22	Adobe InDesign	Francesca Depalma
42	Schermata 2015-09-03 alle 21.33.39	Google Chrome	
42	word mac_47	Microsoft Word	Francesca Depalma
43	Schermata 2015-09-07 alle 18.16.10	Adobe InDesign	
44	Schermata 2015-11-19 alle 17.18.54	iTunes	
44	word mac_4	Microsoft Word	Francesca Depalma
45	Schermata 2015-12-18 alle 16.34.40	Adobe Illustrator	
46	airport digital lentezza	Adobe Acrobat	Francesca Depalma
48	Screen Shot 2015-09-11 at 2.41.38 AM	Adobe InDesign	
48	Schermata 2015-11-03 alle 18.25.39	TextEdit	
49	word mac_8	Microsoft Word	Francesca Depalma
51	Schermata 2015-11-18 alle 10.36.08	Adobe InDesign	
51	word mac_52	Microsoft Word	Francesca Depalma
52	Schermata 2014-08-15 alle 20.38.15	Adobe Illustrator	
54	Michel Ducham	Wikipedia	
54	Schermata 2015-11-21 alle 19.45.14	Adobe Bridge	
55	chromobat, acrochrome	Finder	
55	Schermata 2015-09-05 alle 16.23.39	Adobe InDesign	
55	Schermata 2015-09-23 alle 13.12.43	Finder	

55	Schermata 2015-11-18 alle 19.41.22	Google Chrome	
56	illustrator_strani linguaggi	Adobe Illustrator	Francesca Depalma
56	safari_slowvanity_1	Safari	Francesca Depalma
56	Schermata 2014-04-06 alle 19.59.13	Google Chrome	
57	Schermata 2015-09-07 alle 18.15.02	Adobe InDesign	
57	skype_tante cose contemporaneamente	Skype	Francesca Depalma
58	indesign costellazioni	Adobe InDesign	Francesca Depalma
60	Schermata 2015-05-16 alle 10.15.27	Google Chrome	
60	Schermata 2014-08-29 alle 12.05.30	Wikipedia	
61	Schermata 2015-06-29 alle 12.32.48	Google Chrome	
61	Schermata 2015-09-03 alle 21.39.13	Google Drive	
61	tnt e le ragazze russe omaggio	Google Chrome	
62	i like it broken	Facebook	Francesca Depalma
62	Schermata 2014-10-22 alle 19.30.40	Google Chrome	
62	Schermata 2014-11-13 alle 14.30.09	Google Chrome	
63	lei ce l'ha fatta_great expectation	Facebook	Francesca Depalma
63	Schermata 2014-02-02 alle 21.52.22	Youtube	
63	Schermata 2015-10-11 alle 19.12.05	Facebook	
64	Schermata 2014-04-02 alle 01.38.17	Google Maps	
66	Schermata 2012-06-12 a 11.56.27	Google Chrome	
66	Schermata 2013-09-04 alle 12.24.13	Google Chrome	
66	Schermata 2014-12-03 alle 22.10.06	Google Chrome	
66	Schermata 2015-04-17 alle 10.09.01	Google Chrome	
66	Schermata 2015-11-22 alle 21.12.33	Google Chrome	
66	Schermata 2015-06-10 alle 09.50.10	Google Chrome	
66	Schermata 2014-05-30 alle 15.00.54	Google Chrome	
66	Schermata 2015-02-13 alle 22.42.10	Google Chrome	
66	Schermata 2015-07-10 alle 15.26.15	Google Chrome	
66	Schermata 2015-08-06 alle 18.11.19	Google Chrome	
67	Schermata 2013-10-23 alle 16.12.16	Google Chrome	
67	Schermata 2014-10-14 alle 01.50.28	Gmail	
67	Schermata 2015-11-15 alle 14.21.15	Facebook	
67	Schermata 2015-11-24 alle 15.51.17	Flickr	
68	405512_3063869045640_1587710771	Youtube	Roberto Memoli
68	Fur coats	Facebook	
68	Schermata 2014-11-25 alle 23.31.06	Facebook	Roberto Memoli
68	Schermata 2015-01-14 alle 11.46.07	Facebook	
68	Schermata 2015-08-05 alle 19.29.58	Facebook	
68	Schermata 2015-11-11 alle 17.33.56	Facebook	
68	tropicalia	Facebook	

69	Schermata 2015-02-24 alle 17.28.14	Facebook	
69	fb face feat romano e gufram	Facebook	
69	Schermata 2015-07-13 alle 12.02.31	Facebook	
69	Schermata 2012-12-01 alle 22.32.09	Facebook	
69	Schermata 2014-03-18 alle 11.39.58	Facebook	
69	Schermata 2015-01-26 alle 13.12.49	Facebook	Roberto Memoli
69	Schermata 2015-11-12 alle 10.17.37	Facebook	
70	Schermata 2014-10-22 alle 20.43.51	Google Chrome	
72	forty_times_hello_1	Facebook	Pietro Amoruoso
72	forty_times_hello_2	Facebook	Pietro Amoruoso
72	forty_times_hello_3	Facebook	Pietro Amoruoso
72	forty_times_hello_4	Facebook	Pietro Amoruoso
72	forty_times_hello_5	Facebook	Pietro Amoruoso
72	forty_times_hello_6	Facebook	Pietro Amoruoso
72	forty_times_hello_7	Facebook	Pietro Amoruoso
72	forty_times_hello_8	Facebook	Pietro Amoruoso
72	forty_times_hello_9	Facebook	Pietro Amoruoso
72	forty_times_hello_10	Facebook	Pietro Amoruoso
72	forty_times_hello_11	Facebook	Pietro Amoruoso
72	forty_times_hello_12	Facebook	Pietro Amoruoso
72	forty_times_hello_13	Facebook	Pietro Amoruoso
73	forty_times_hello_14	Facebook	Pietro Amoruoso
73	forty_times_hello_15	Facebook	Pietro Amoruoso
73	forty_times_hello_16	Facebook	Pietro Amoruoso
73	forty_times_hello_17	Facebook	Pietro Amoruoso
73	forty_times_hello_18	Facebook	Pietro Amoruoso
73	forty_times_hello_19	Facebook	Pietro Amoruoso
73	forty_times_hello_20	Facebook	Pietro Amoruoso
73	forty_times_hello_21	Facebook	Pietro Amoruoso
73	forty_times_hello_22	Facebook	Pietro Amoruoso
73	forty_times_hello_23	Facebook	Pietro Amoruoso
73	forty_times_hello_24	Facebook	Pietro Amoruoso
73	forty_times_hello_25	Facebook	Pietro Amoruoso
73	forty_times_hello_26	Facebook	Pietro Amoruoso
74	Schermata 2014-12-01 alle 22.39.23	Google Chrome	
78	Schermata 2015-05-01 alle 10.55.41	Google Chrome	

Valeria Mancinelli
Chiara Nuzzi
Stefania Rispoli

A collection of trophy images

The trophy image is one of the main symbols of the colonial age. Commonly, it was used to represent the colons at the end of a hunt action, while showing the captured preys and the natives who helped in the enterprise.

Recently, the term has been employed again in other contexts. As an example, some scholars like Suvendrini Perera read the stolen pictures spread about the Abu Ghraib jails as well as those from international terrorist attacks as trophy images, in which conquerors and defeated subjects share the same framing and are both victims of the same power: the atrocity of war. The destruction of historical monuments and statues committed by ISIS militants, as well as the images depicting Bardo Museum after the terrorist attack of March 2015 perpetuate the same violence and lead us thinking to those artworks that were smuggled and partially scattered by the nazis during the Second World War. If compared with the last ones, today's images seem to be born with a different awareness, or rather thanks to it, which can be summed up as the power to catch millions of people in real time.

A collection of *trophy images* faces such a position, widening also over the journalistic documentation and over that of the military camp and

applying it to the contemporary social, political and visual environment.

In our daily life, where people use images and their ostentation over and over again — some valuations reveal that the amount of daily images posted on line is about 1,8 billions — which are the trophy images and to what extent do they work in shaping our reality?

The following pages aims to structure itself as a collection of images coming from the personal archive of a heterogeneous group of web users close to the publication's curators. Each of them, after having read a brief definition of the trophy image, accepted to give an example, a theme's interpretation: be it a private photo or a public domain image.

The result is a gallery of very different pictures: from stolen snapshots to historical photos and contemporary images, where, often, the aesthetic or documentary intent is subordinated to the need of self-affirmation. Such images finally imply a conquest, not necessarily in a physical dimension but also in a cultural one, and a power reaction that executes itself out and inside the picture frame between the conqueror and the prey, but also between the spectator and the represented subject.

A large part of these images are politicians', common people or celebrities' selfies, ideated to fix a moment of highest self-affirmation in the daily-life, other ones look like spontaneous images actually originated in order to share very punctual propaganda messages from time to time. Along the last year, some of them went around the world becoming viral. However, it would not be a surprise if many of those would be forgotten as quickly as they reached celebrity, revealing once more the consumption process affecting the life of social and cultural products as those of images.

 A collection of trophy images is a reflection on the status of the image today, some of them show the several aspects of the definition of the trophy both in the past and today, others are part of small series that explore in deep a particular aspect of such a visual phenomenon.

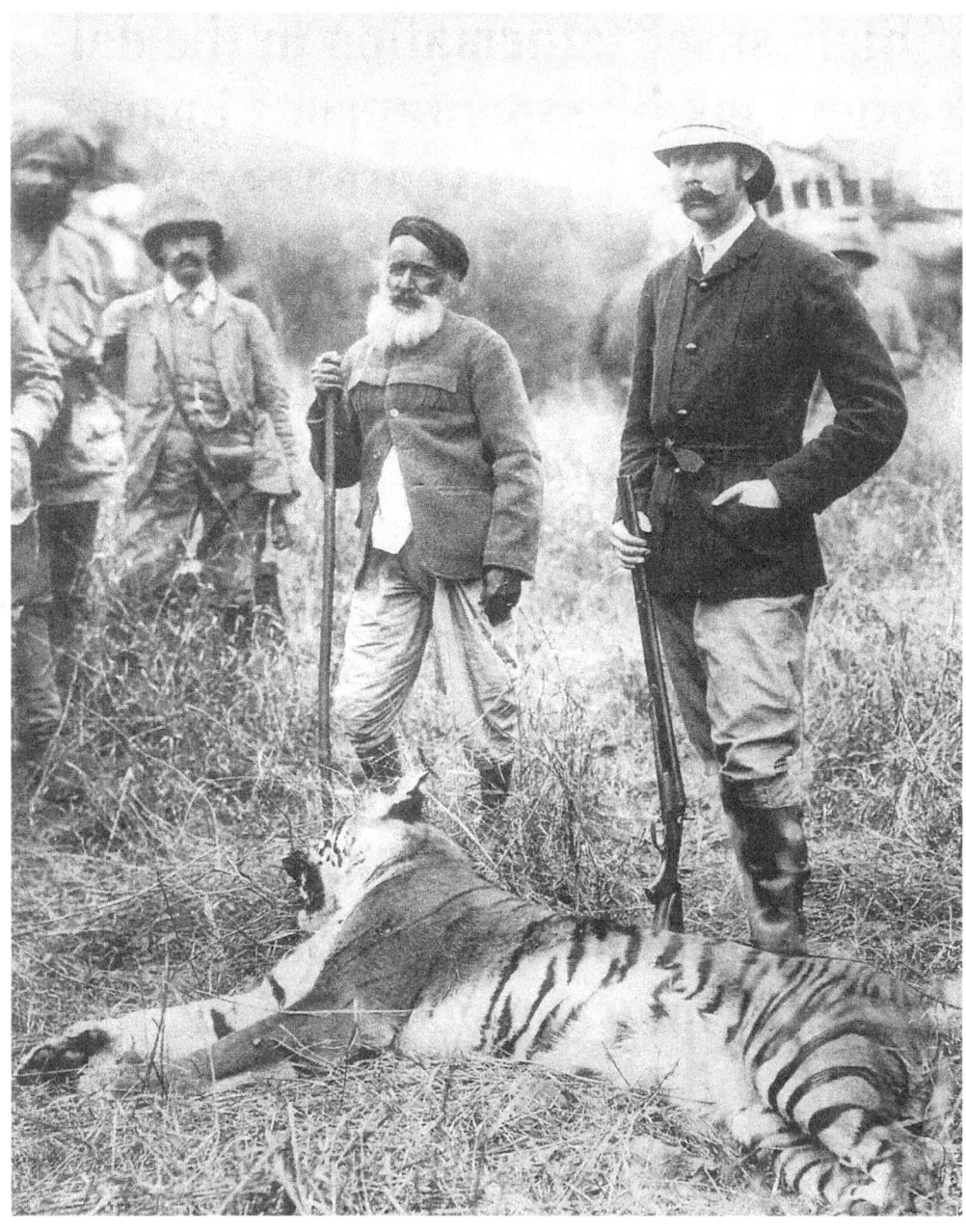

Franz Ferdinand in Nepal, 1983

A COLLECTION OF TROPHY IMAGES

89

MANCINELLI NUZZI RISPOLI

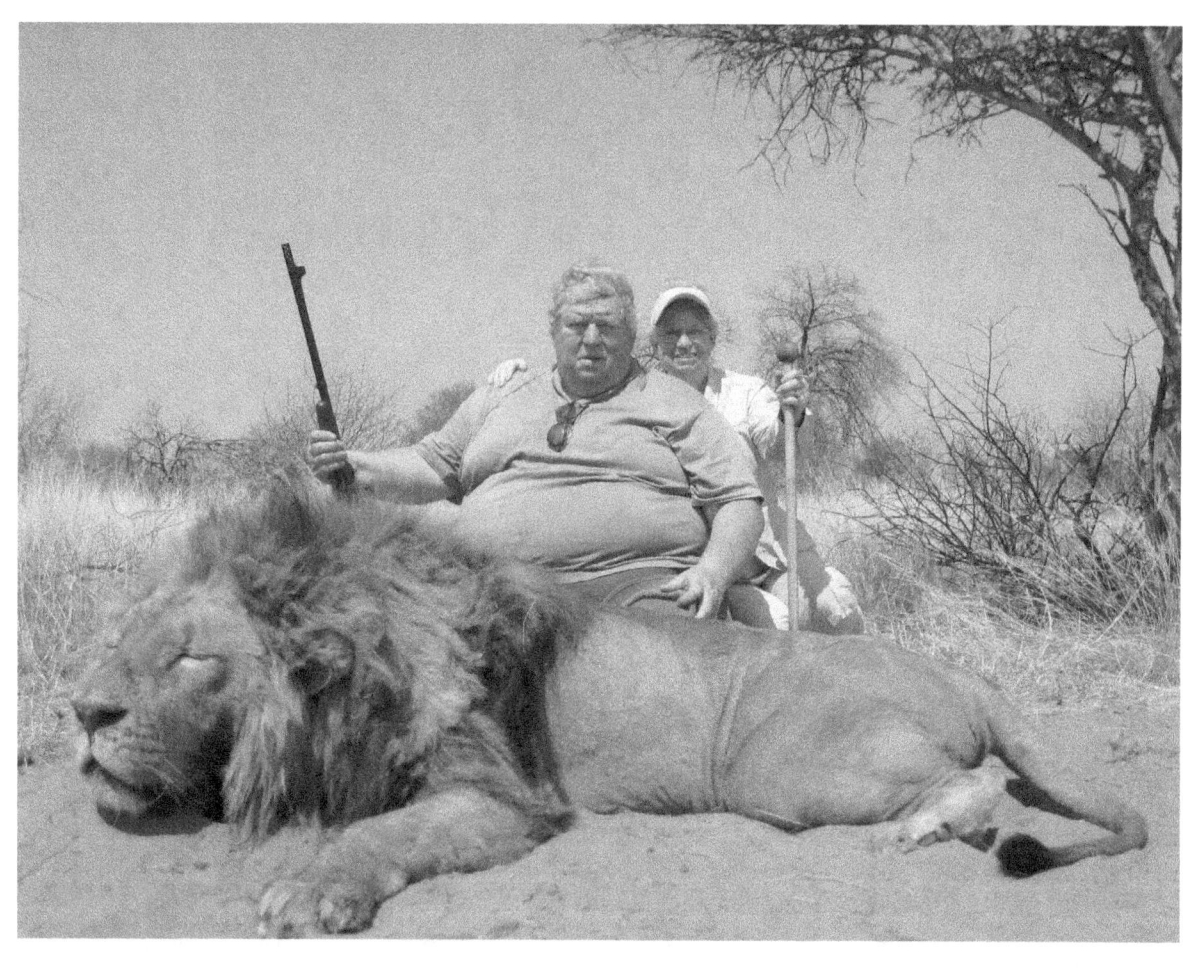

A COLLECTION OF TROPHY IMAGES

91

MANCINELLI NUZZI RISPOLI

The Sleeping Lion

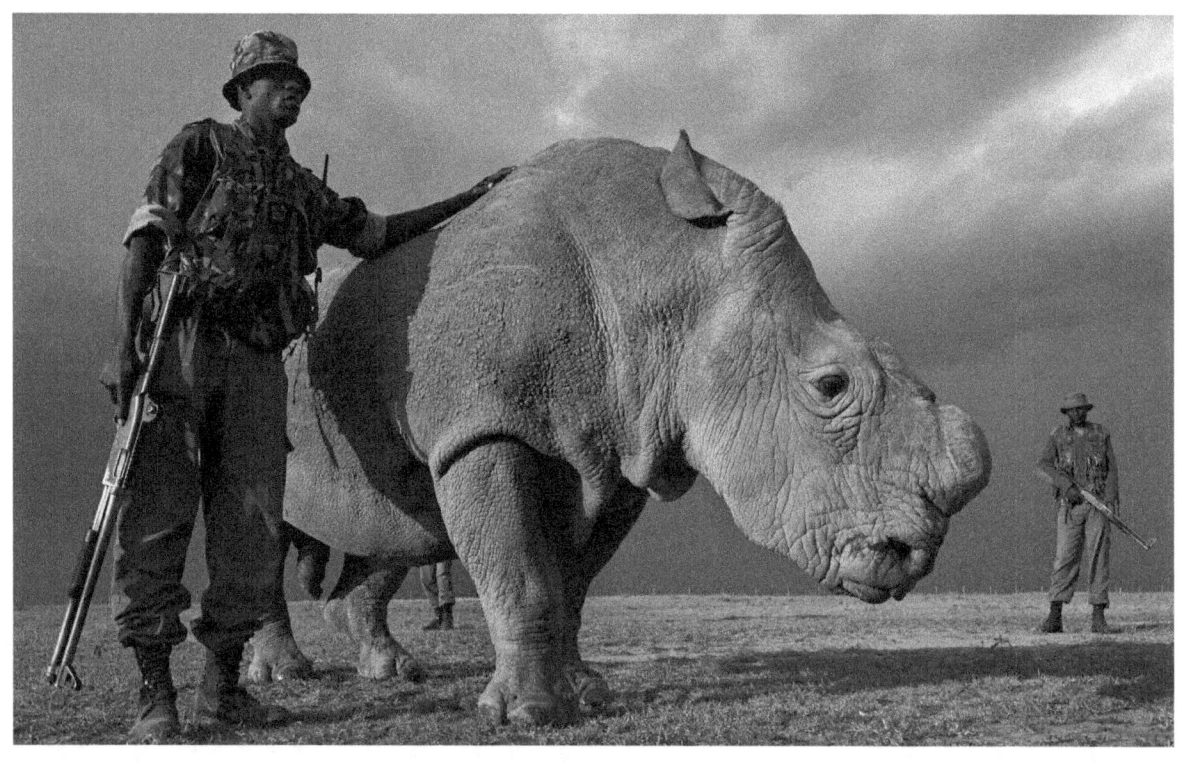

Symbolic Emergency: The Last Male <White> Rhinoceros is both a trophy
on the rack of the Human Sovereignty Campaign, and a living artifact
in the collection of the Museum of Colonization. Extinction is perhaps
Nature's ultimate performance of autonomy, its will defying our contradictory
desire to both massacre AND maintain it. These Symbolic Priests offer
their lives to protect this bloody artifact, whose survival is secondary
to the meaning we inscribe upon it.

(excerpt from *Tactical Extinction*, an exhibition/publication
from The Museum of Artificial Histories)

Welcome to the world of Scambaiting!

Get the latest Anti Scam News and Information here.

Does somebody want to transfer millions of dollars into your account?
Does someone want to pay you to cash cheques and send them the money?
Met a new friend/penpal on a friendship/dating site who's asking you for money?
Has a dying person contacted you wanting your help to give his money to charity?
Have you sold an item and are asked to accept a payment larger than the item amount?

IT'S A SCAM!

Don't fall for common scams like this - fight them!

So what is scambaiting? Well, put simply, you enter into a dialogue with scammers, simply to waste their time and resources. Whilst you are doing this, you will be helping to keep the scammers away from real potential victims and screwing around with the minds of deserving thieves.

It doesn't matter if you are new to this sport or a hardened veteran; if you are wasting the time of a scammer, or frustrating them in any way well that's good enough for us, and we would welcome you to join with our now very large community.

Although this site concentrates mainly on the Nigerian 419 scam, we are happy to deal with other types of scams if and when the opportunity arises. We also have a large team of experts dedicated to the removal and closure of fake scammer banks and sites.

Even if you are a newcomer, much fun can be had and at the same time you will be doing a public service. If you are new to this game and need to know what scambaiting is all about, please click on the 419 FAQ link at the top of the page. See also Baiting Tips for information on getting started on this great cyber-sport 😊

We encourage everyone to contribute to this site and the good cause of scambaiting by joining in the fun on the FORUM where you can meet new friends and seek expert help, tips and advice on anti-scamming. User participation is absolutely encouraged. Please help us to raise awareness the world over!

Do not be fooled into thinking scammers operate from a specific part of the world. Advance fee fraud scammers are a world-wide menace, and they operate from every continent. These scammers range from small one-man-band criminals scamming a few thousand dollars a year, to highly organised groups raking in hundreds of thousands of dollars a month.

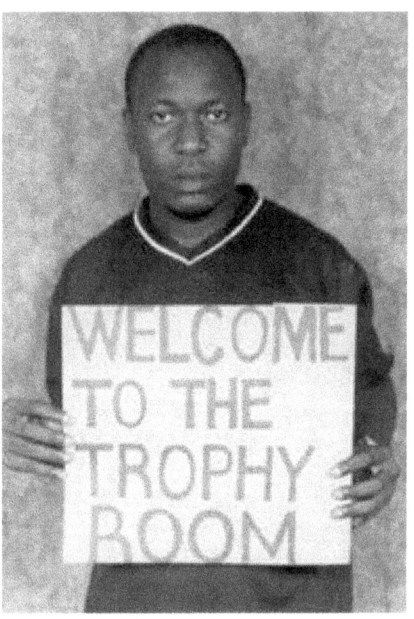

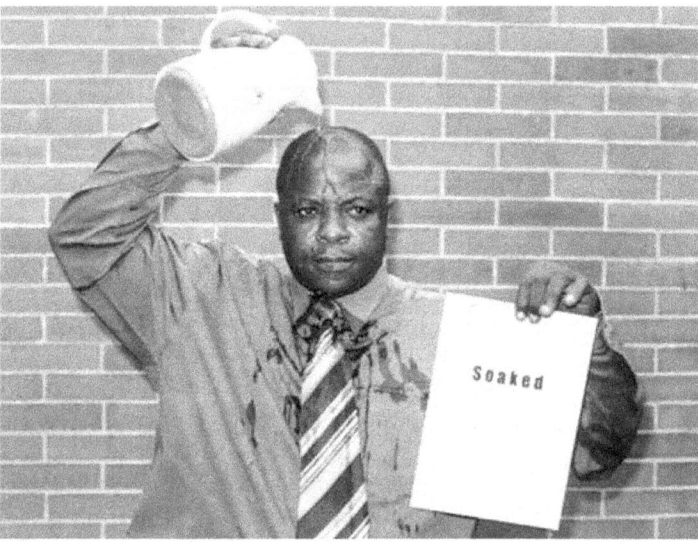

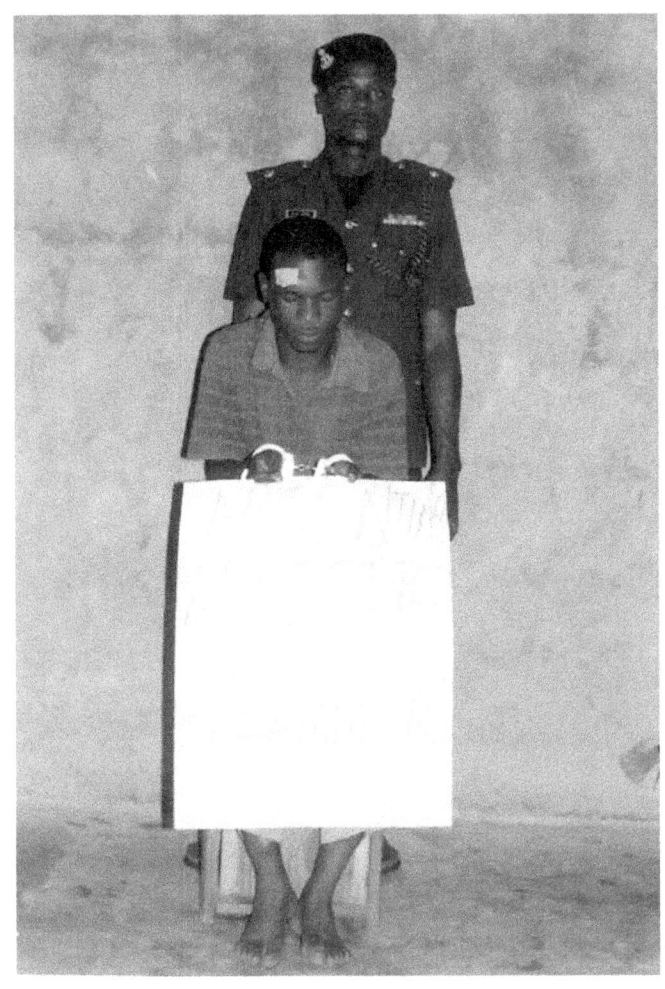

Homepage 419eater

Welcome to the Trophy Room

Submitted By: Mr. Fishe.
Scammer Name: Prince Joe Eboh.
Website: N/A

Submitted by: Argentino.
Scammer Name: 'Mary' Murphy & Co.

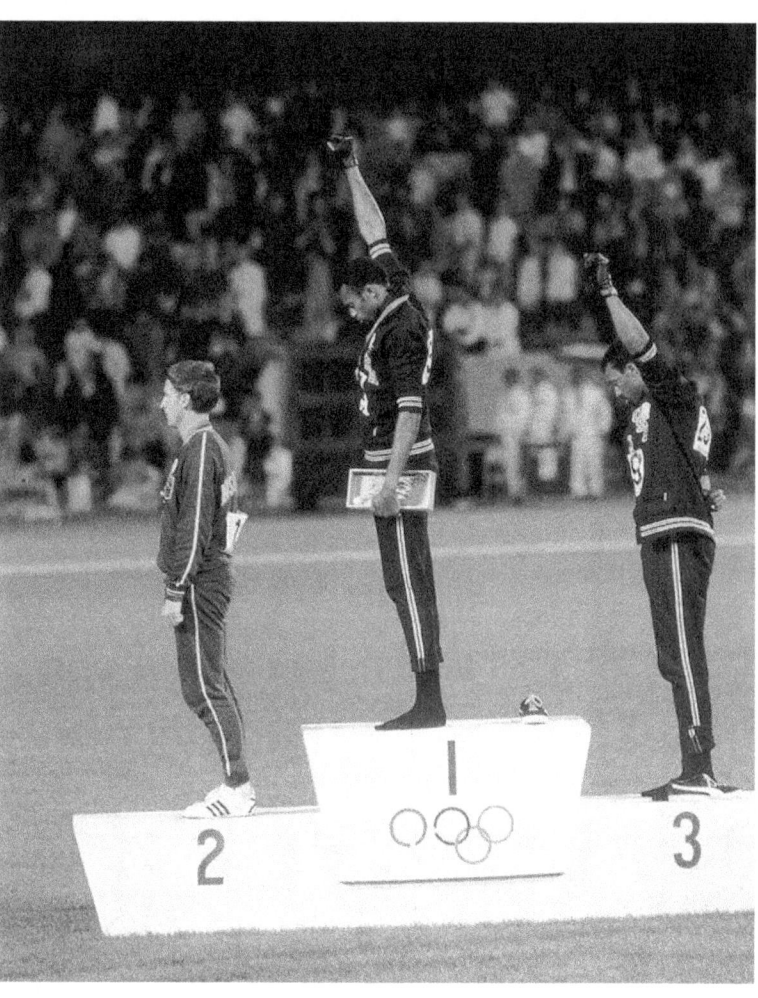

Tommie Smith, John Carlos and Peter Norman, Mexico City 1968

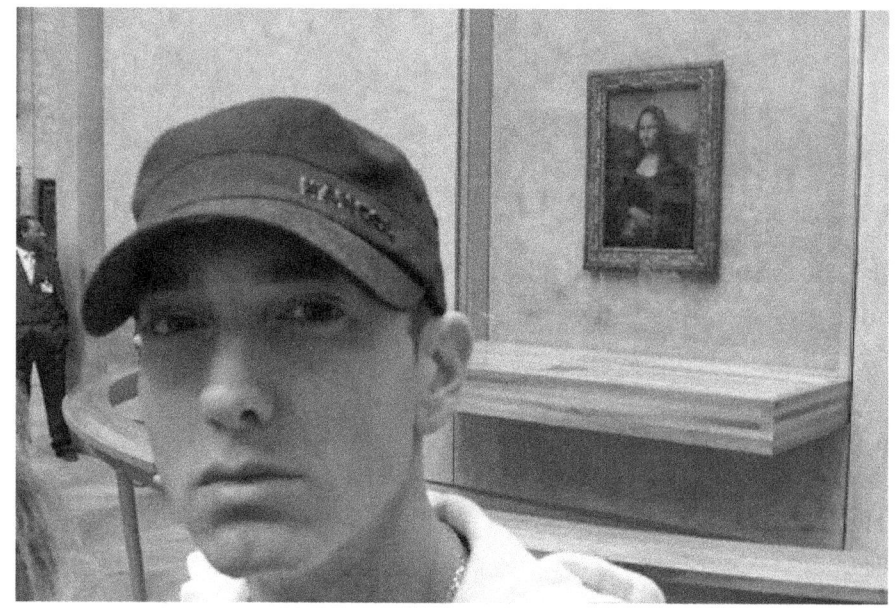

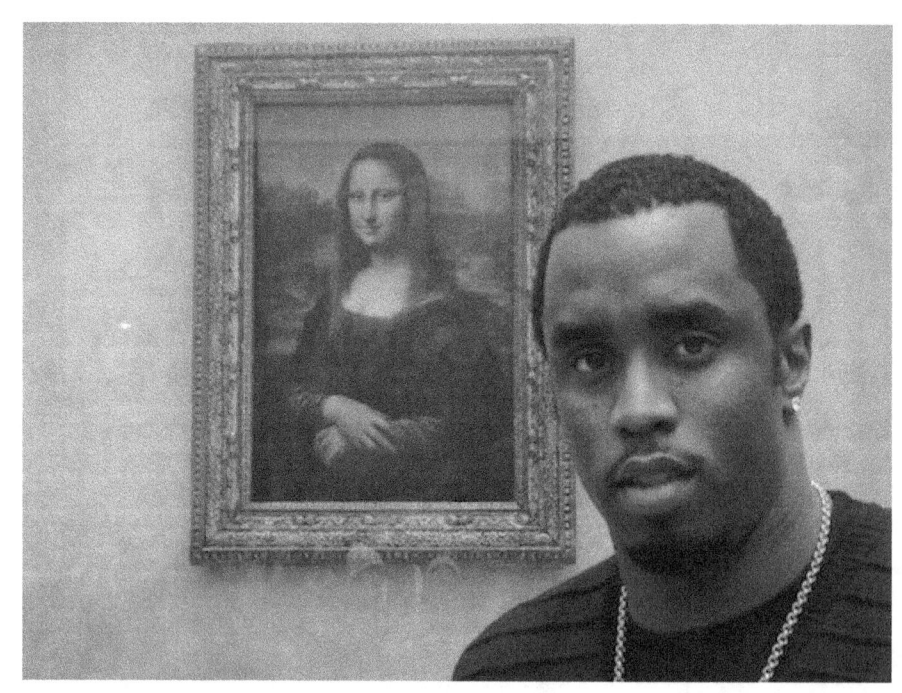

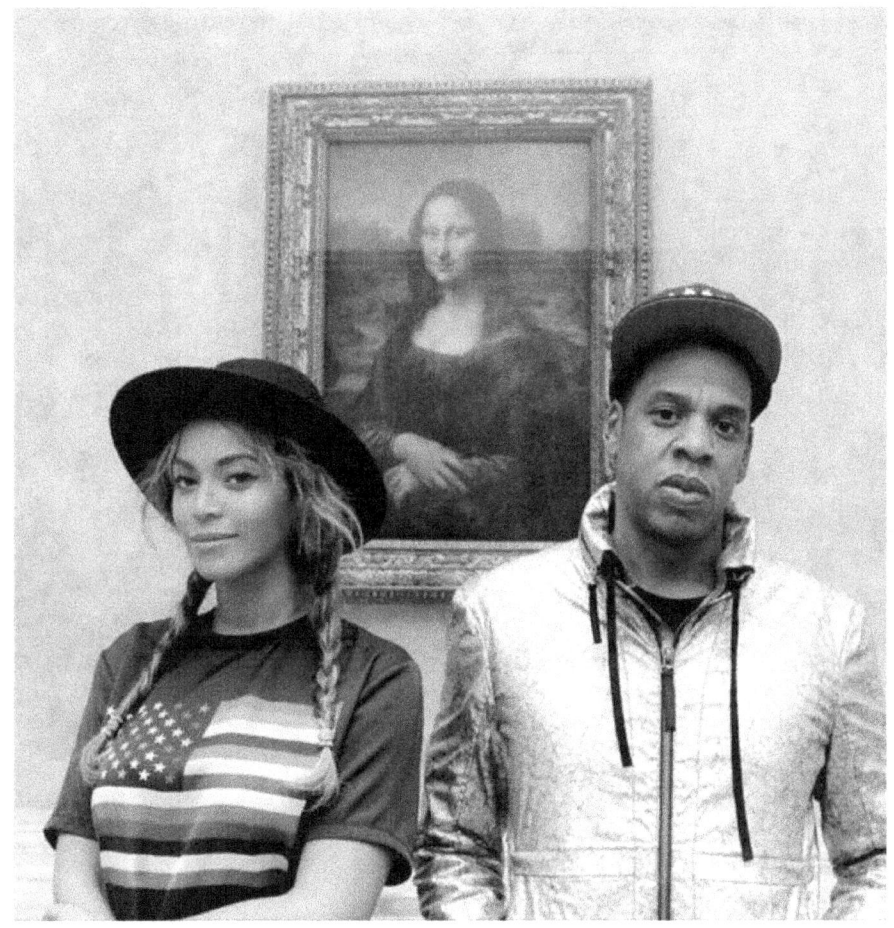

Eminem (2010), P Diddy (2011), Beyonce and Jay-Z (2014) posing with the Mona Lisa

PHOTODUMP

100

IN MY COMPUTER #11

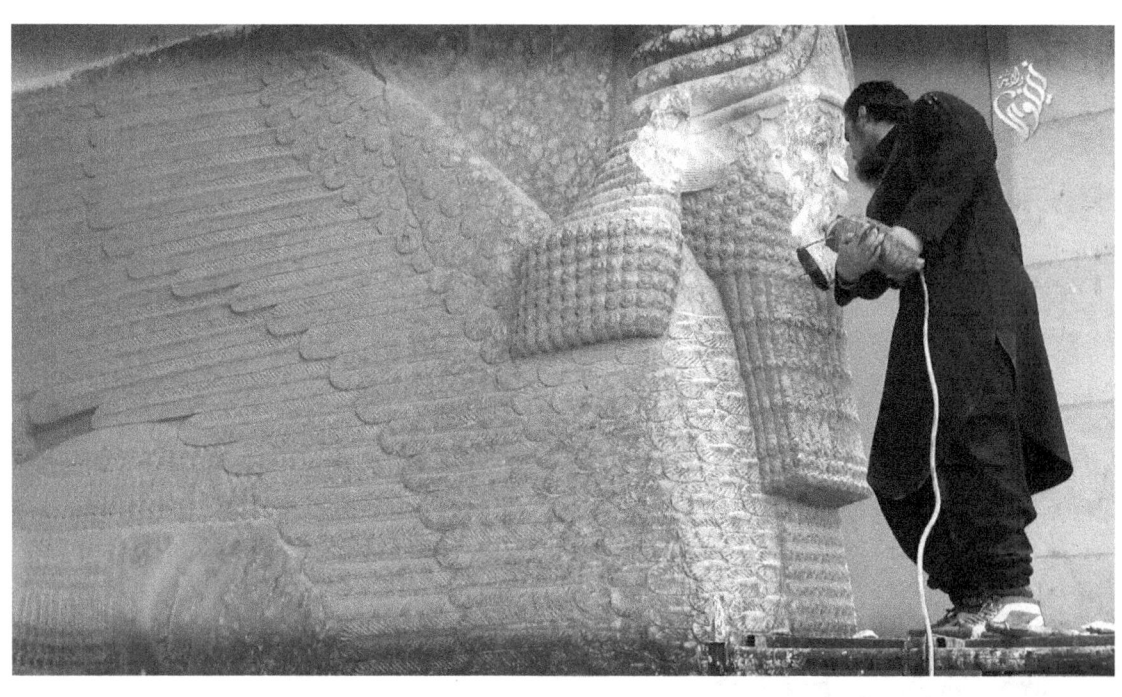

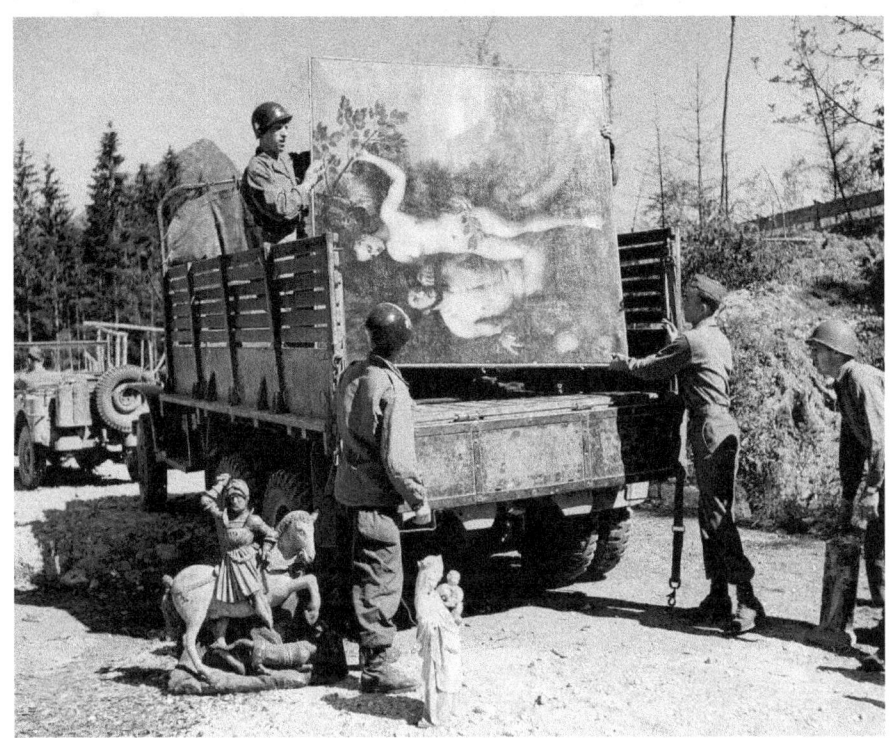

Picture released by ISIS media organization depicting a member of ISIS while destroying a statue in the central museum of Mosul, Iraq, February 2015

American troops of the 101st Airborne load a truck with recovered art treasures reportedly stolen by German Reichsmarschall Hermann Goering, April 1945

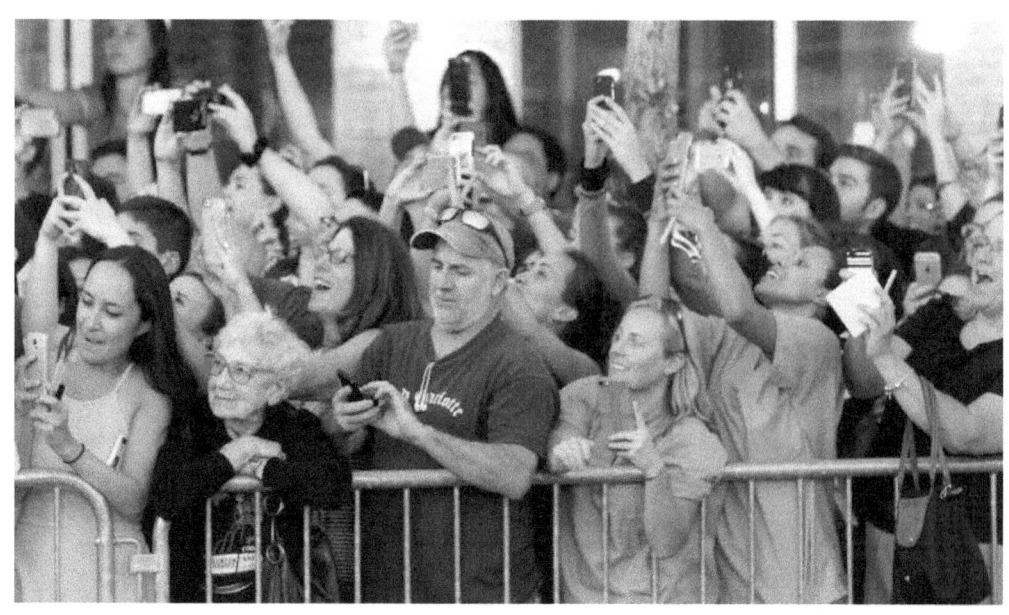

Black Mass red carpet premiere in Boston, September 2015.
Image by John Blanding (Boston Globe)

PHOTODUMP

104

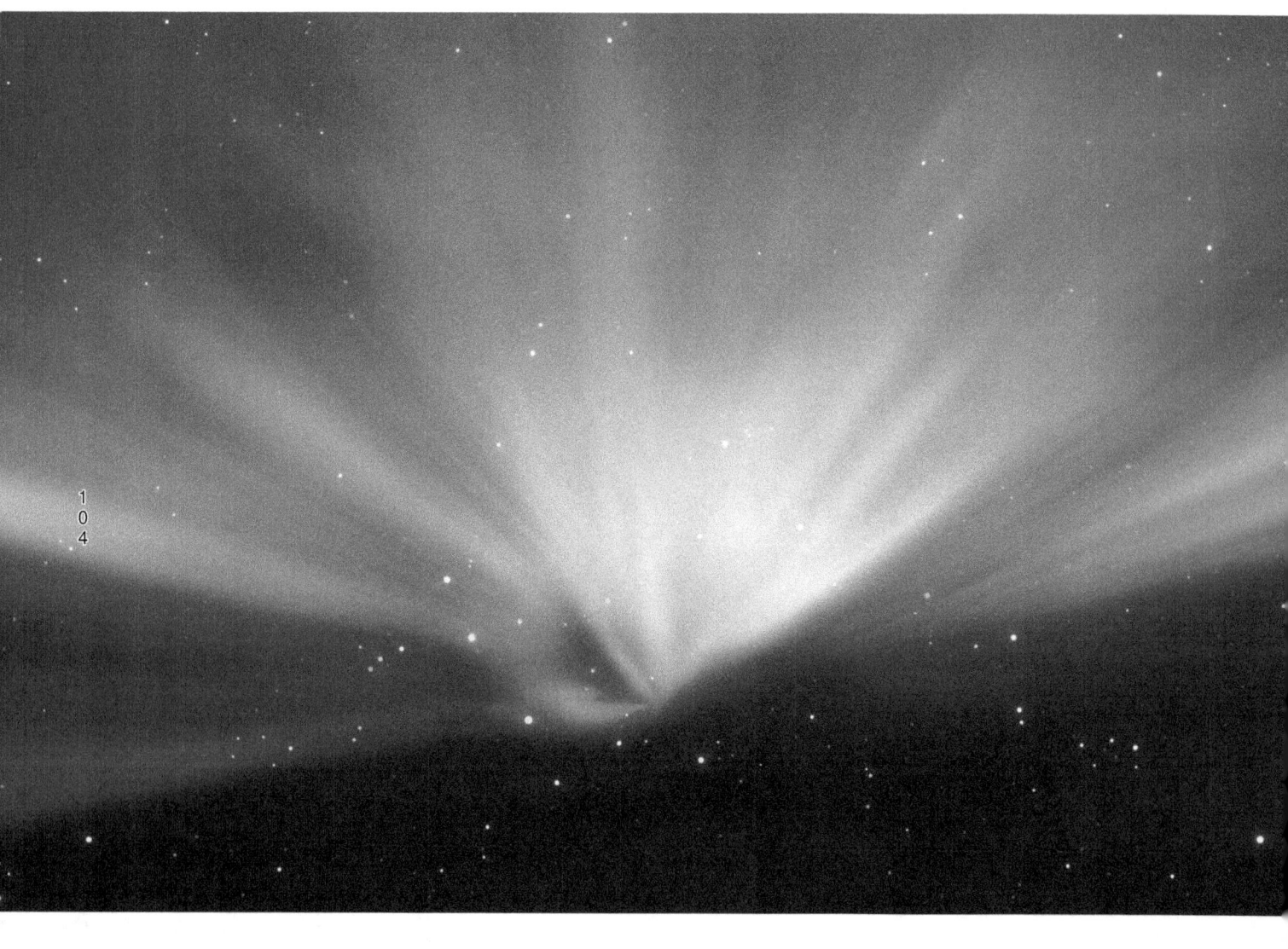

IN MY COMPUTER #11

Aurora has been the default Mac OS X desktop since 2007

Barbican

Barbican criticises protesters who forced Exhibit B cancellation

Withdrawal of anti-slavery exhibition hailed as victory by campaigners, but Barbican says cancellation has implications for artistic freedom

Hugh Muir

Wednesday 24 September 2014 14.50 BST

Shares Comments
1567 885

 Save for later

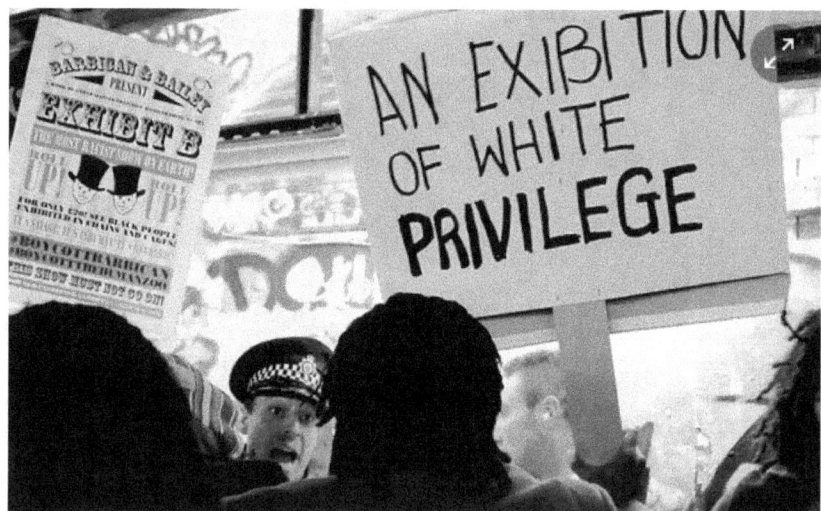

Protesters gather at the Vaults Gallery during a rally that led to Exhibit B by South African artist Brett Bailey being cancelled. Photograph: Thabo Jaiyesimi/Demotix/Corbis

Exhibit B, an anti-slavery exhibition featuring black actors chained and in cages by the white artist Brett Bailey. The black community protested against slavery put on display by a white man

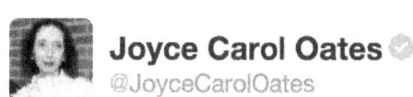 **Joyce Carol Oates** ✓ + Follow
@JoyceCarolOates

All we hear of ISIS is puritanical & punitive; is there nothing celebratory & joyous? Or is query naive?

RETWEETS **375** LIKES **265**

11:28 AM - 22 Nov 2015

Jonathan Kennedy @getradified · Nov 23
@joycecaroloates @id4ro Jesus fucking christ.

 ↩ ↻ 1 ♥ 14 ⋯

 JoeyJoeJoeJrShabadoo @SideshowJon36 · Nov 23
@JoyceCarolOates They rape children. Can you find anything joyous in that?

 ↩ ↻ 1 ⋯

 Red Kahina @RedKahina · Nov 22
@JoyceCarolOates how would you describe the joyousness of the SS in Auschwitz? Are their ecstasies of great interest?

 ↩ ↻ 12 ♥ 15 ⋯

View other replies

 Karen @kazahann · Nov 22
@EMQuangel @RedKahina @JoyceCarolOates she can't understand why concentration camps have to be so dour & tedious.

 ↩ ↻ 2 ♥ 5 ⋯

 Amy Selwyn @amyselwyn · Nov 22
@JoyceCarolOates This question is beyond tone deaf. They crucify and behead. They murder. If they experience joy I don't give a shit.

 ↩ ↻ 16 ♥ 134 ⋯

A COLLECTION OF TROPHY IMAGES

MANCINELLI NUZZI RISPOLI

The impossibility to accept that there might be beauty and attraction
in a movement that in our capacity to interpret we can only see as horrible
is the realization that we are the actual trophy in this image.

PHOTODUMP

110

IN MY COMPUTER #11

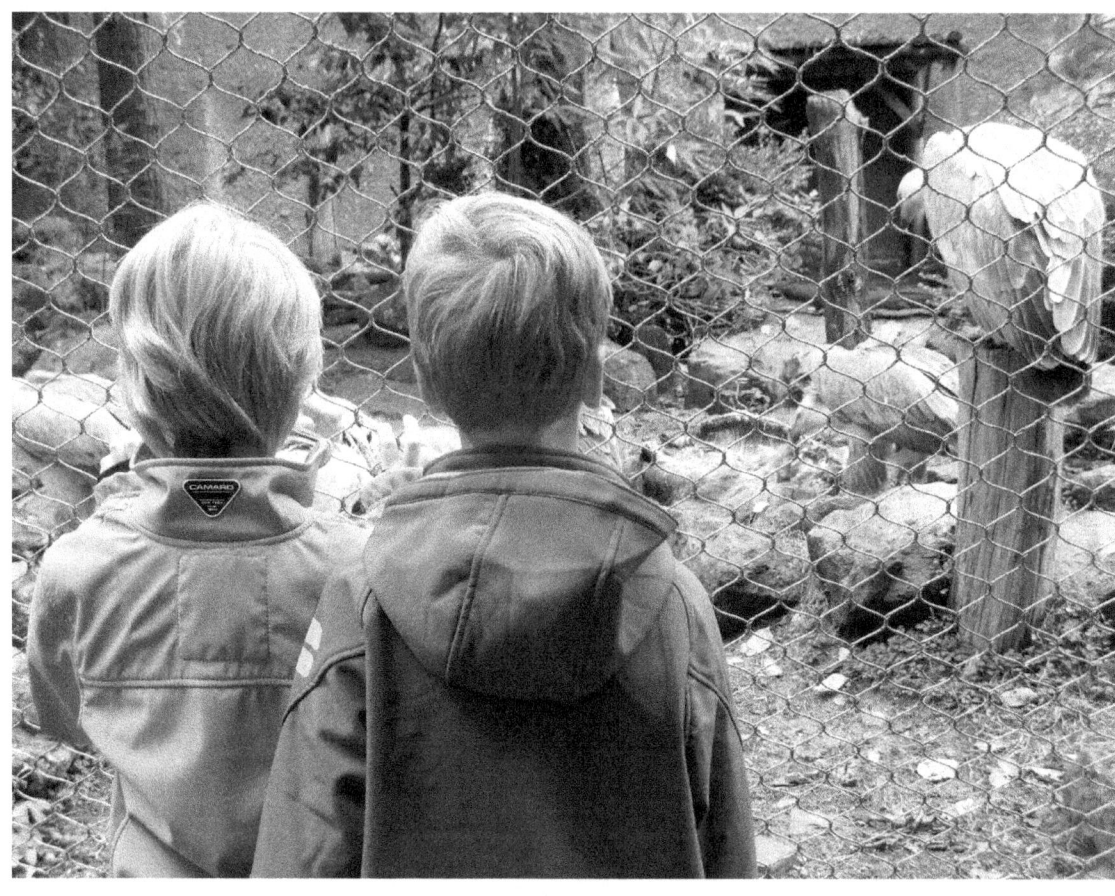

A COLLECTION OF TROPHY IMAGES

111

MANCINELLI NUZZI RISPOLI

Untitled

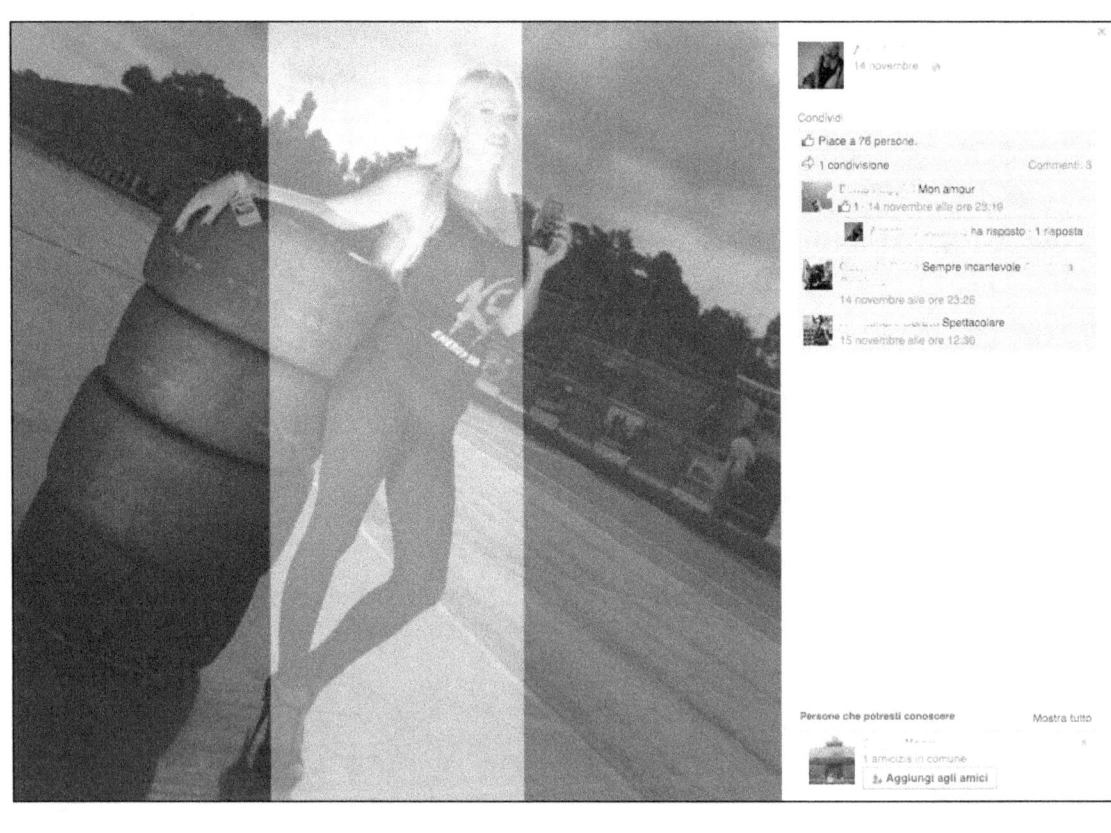

A COLLECTION OF TROPHY IMAGES

113

MANCINELLI NUZZI RISPOLI

Facebook homage to the victims of 13th November 2015 in Paris

PHOTODUMP

114

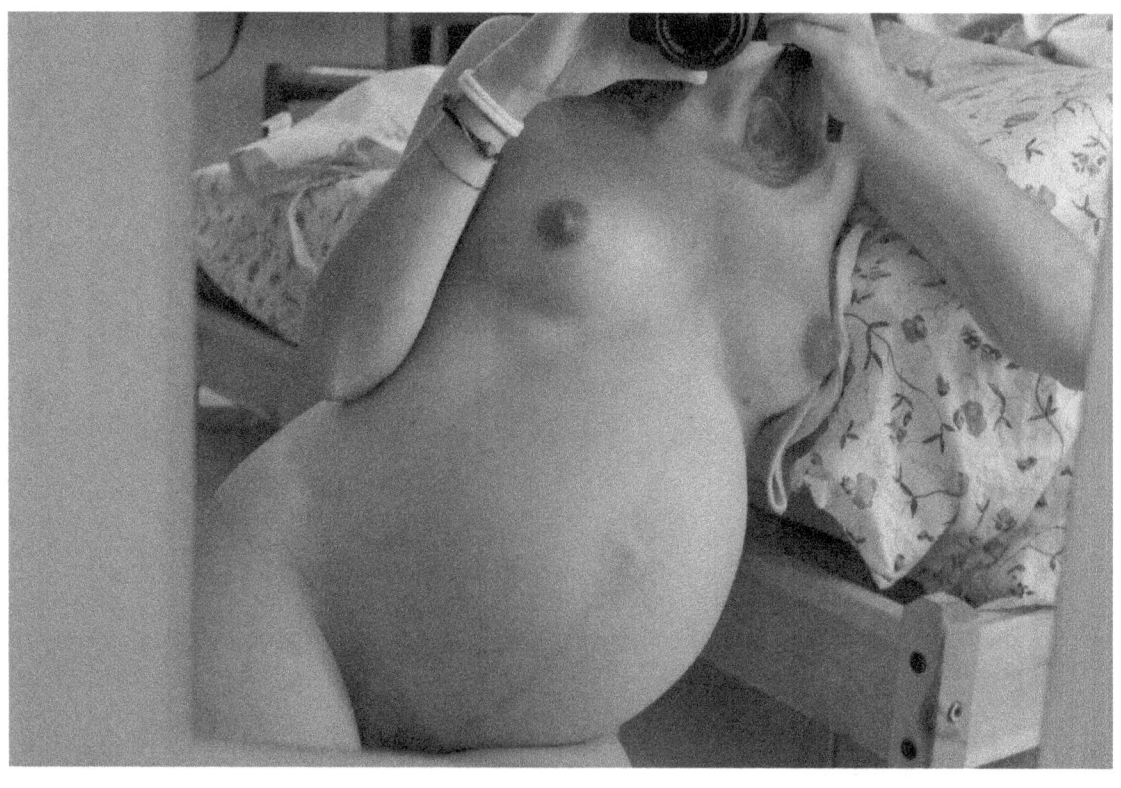

IN MY COMPUTER #11

Portrait

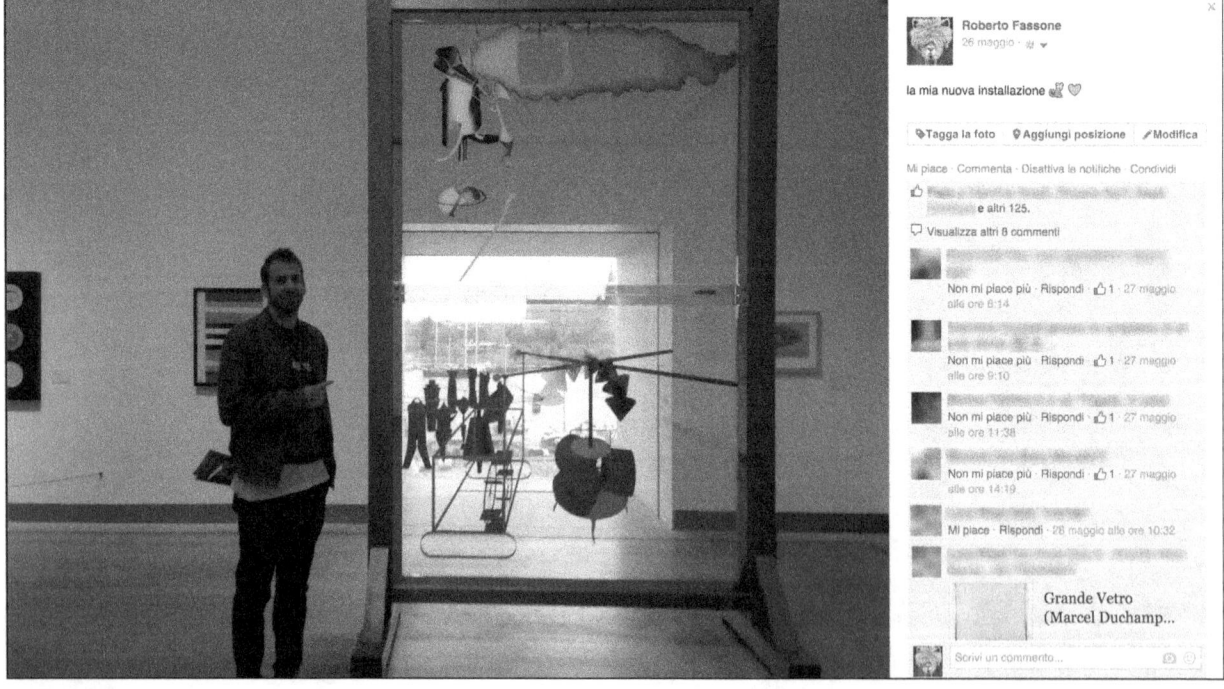

Roberto Fassone, *Le Grand Verre*, 2015

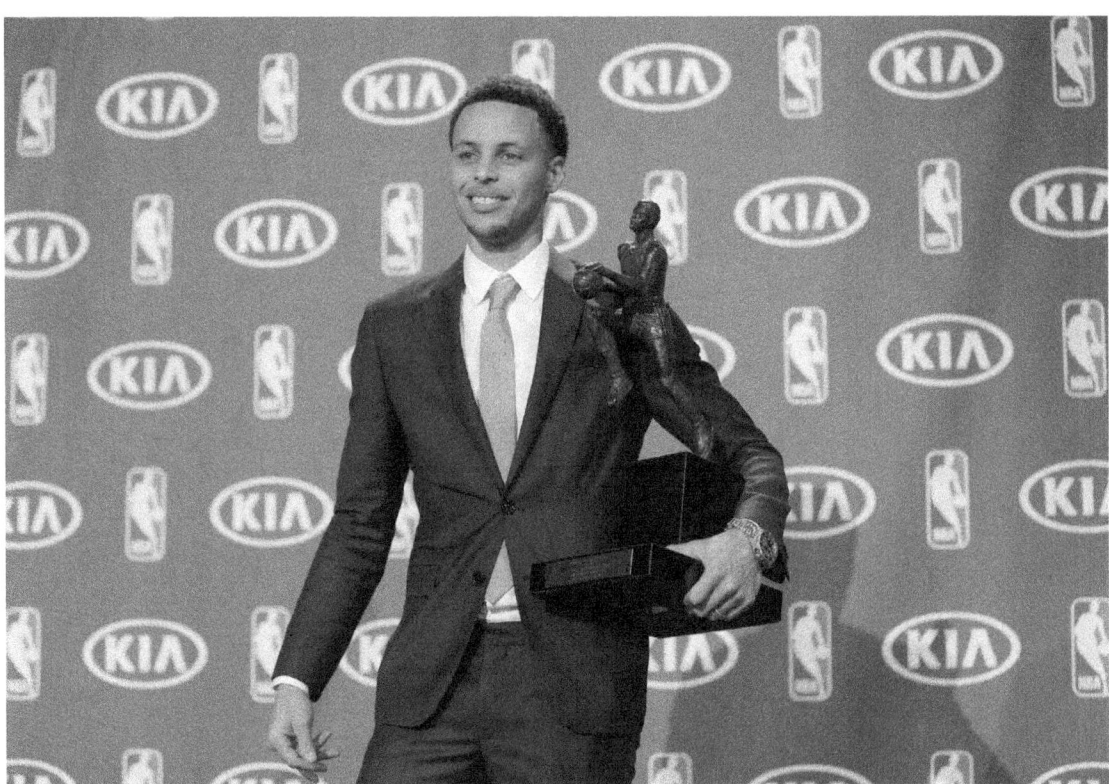

Asteroids (Atari Inc., 1979)

PHOTODUMP

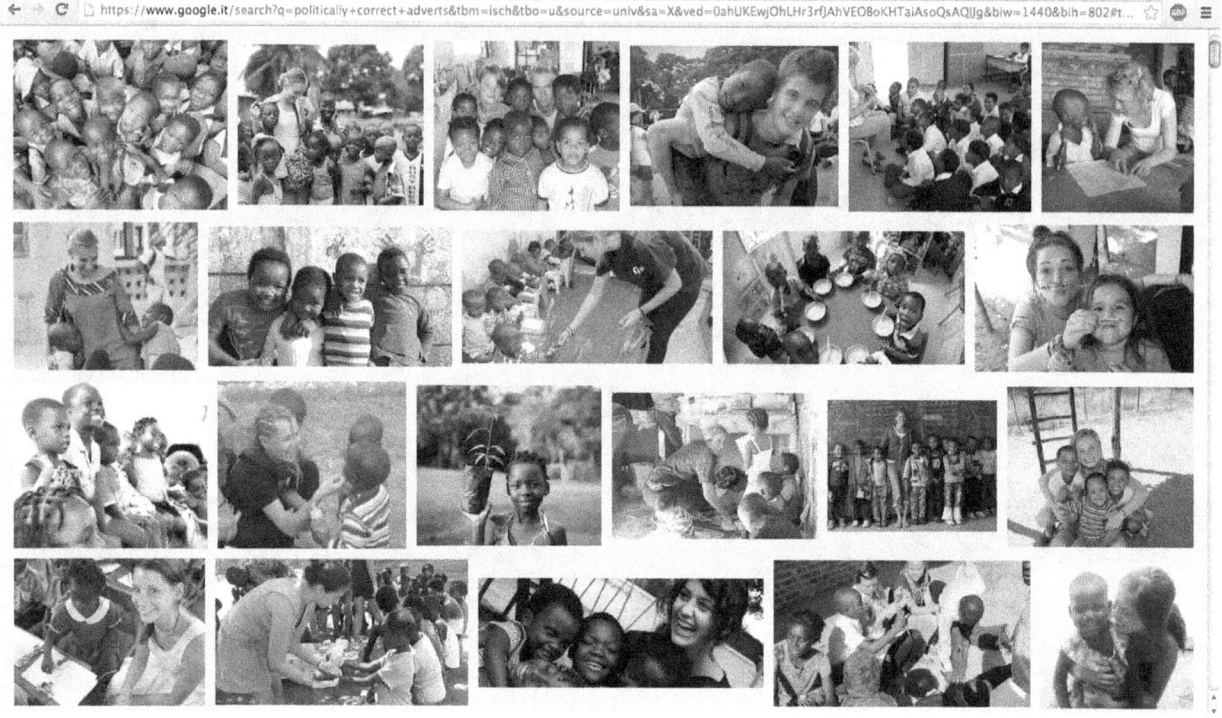

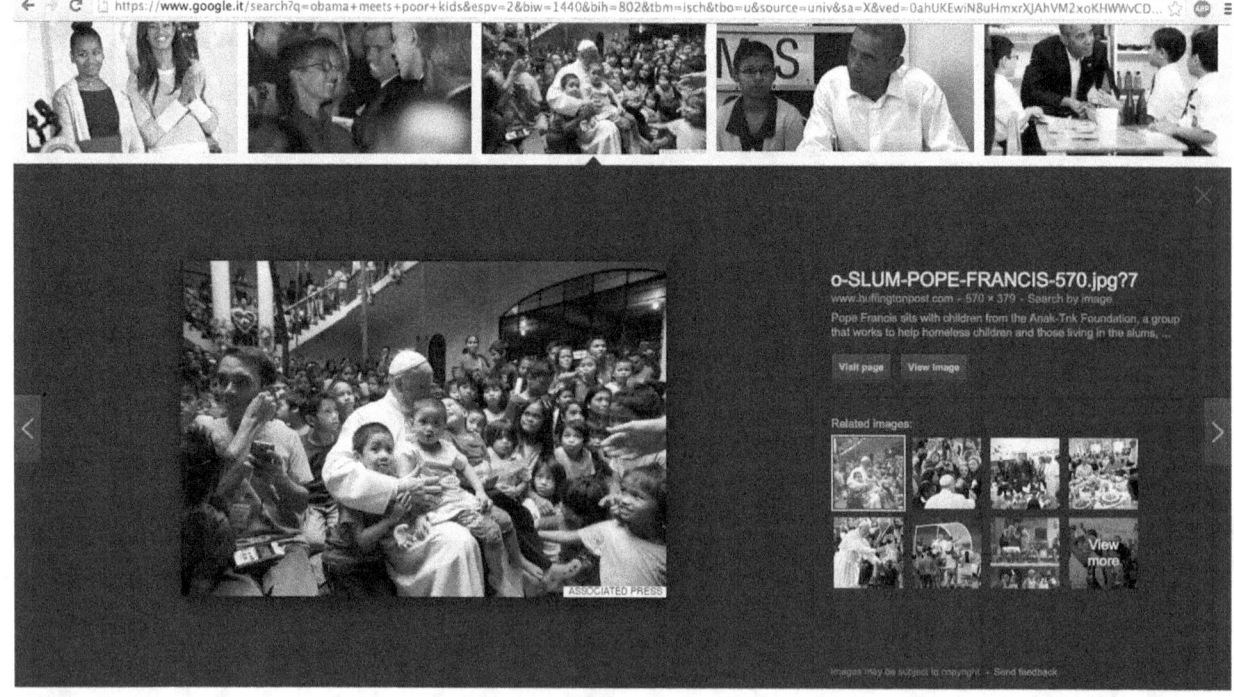

IN MY COMPUTER #11

Untitled

SOMALIA The historic tree of Ual Ual, from where we first opened fire on December 5th 1934, arrives in Mogadishu after a long journey through the Ogaden and the Benadir. The interesting relic will be exhibited at the Triennale d' Oltre Mare and then destined to the Colonial Museum in Rome

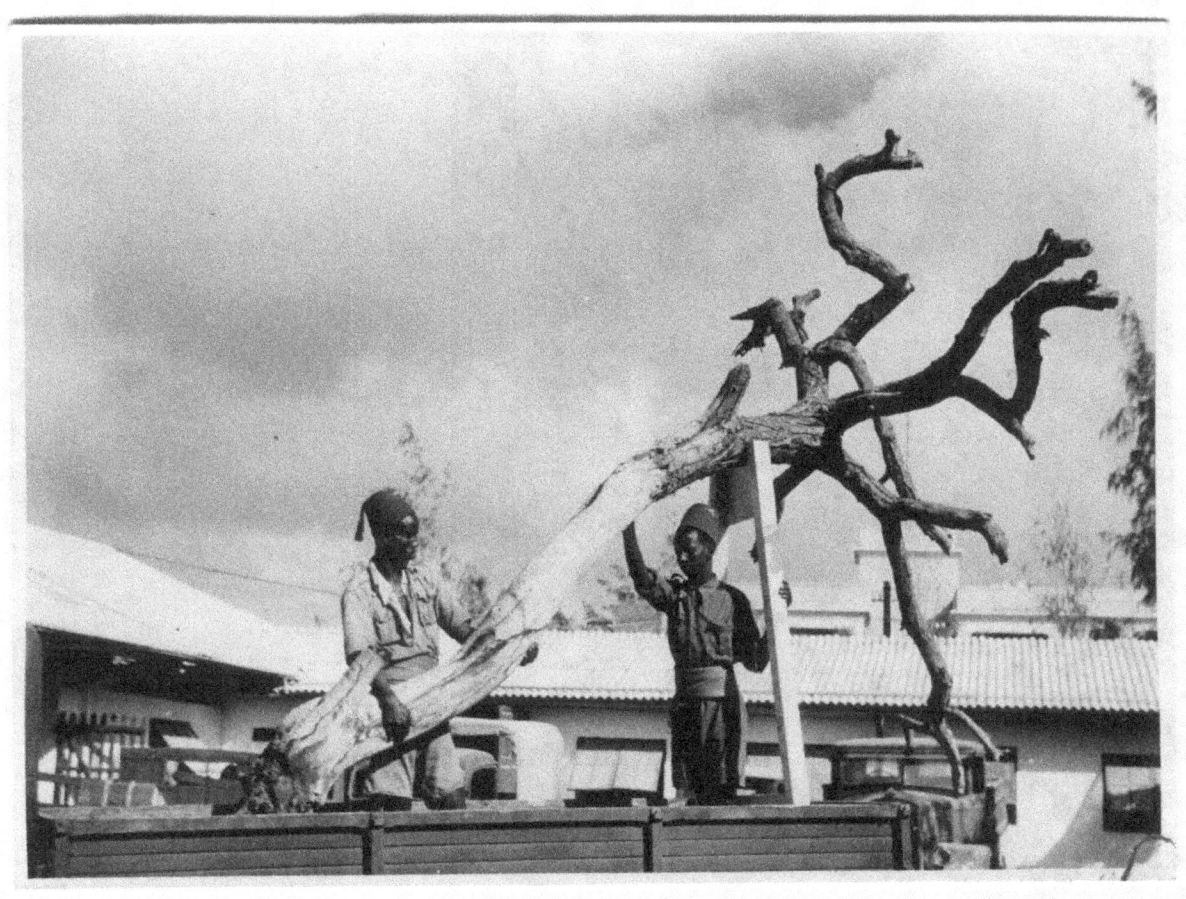

Shipping of the Three of Ual Ual, Somalia, 1934

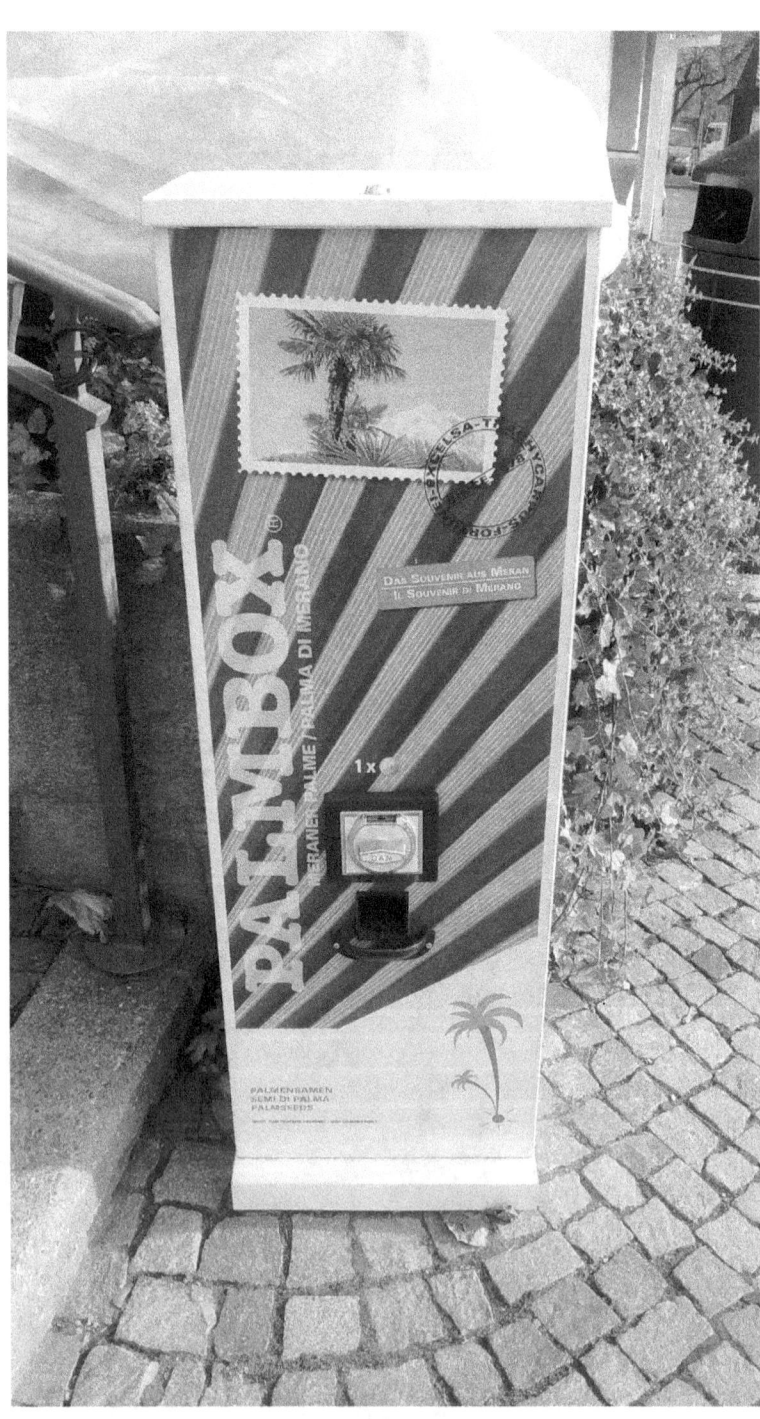

Palm seeds vending machine, Tyrol, (BZ), 2015

Stephen Curry receives NBA MVP Trophy

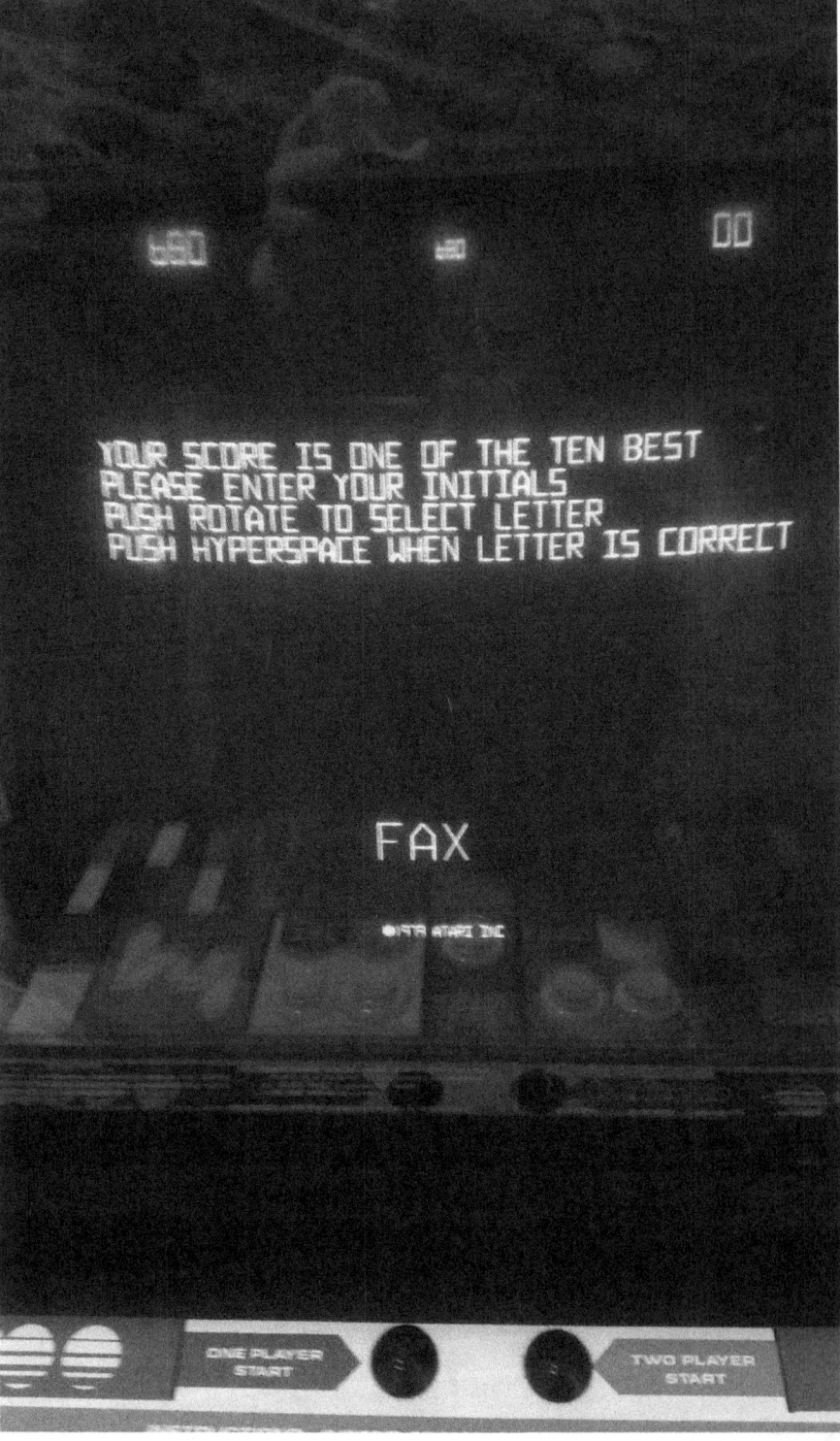

Palais Mamming, Civic Museum collections of Merano (BZ), 2015

Contemporary ex-voto, Madonna dei Miracoli Church, Casalbordino (CH), Italy

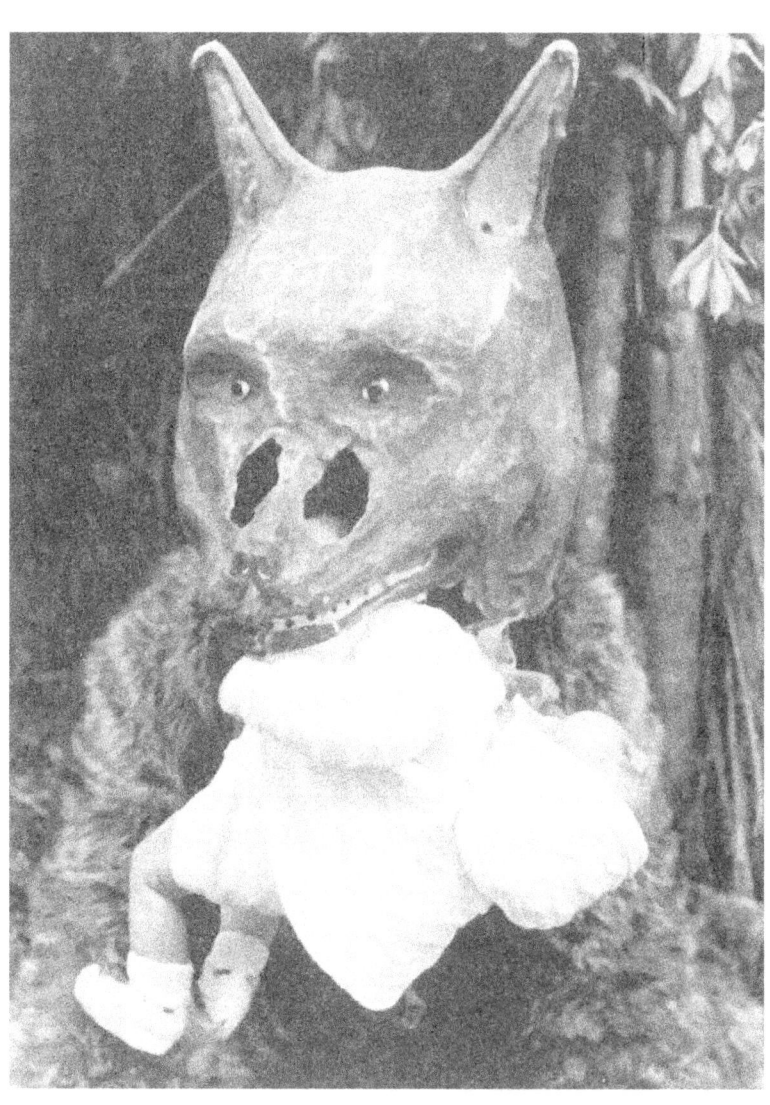

Reenactment of the myth of the baby and the wolf, Abruzzo, Italy

Meeting moment between a local native and a Spanish colonizer, Leleque Museum, Argentina

Undeclared election campaign, Milan

PHOTODUMP

136

IN MY COMPUTER #11

Chichicastenango Market, Vanity and Misery, 2015

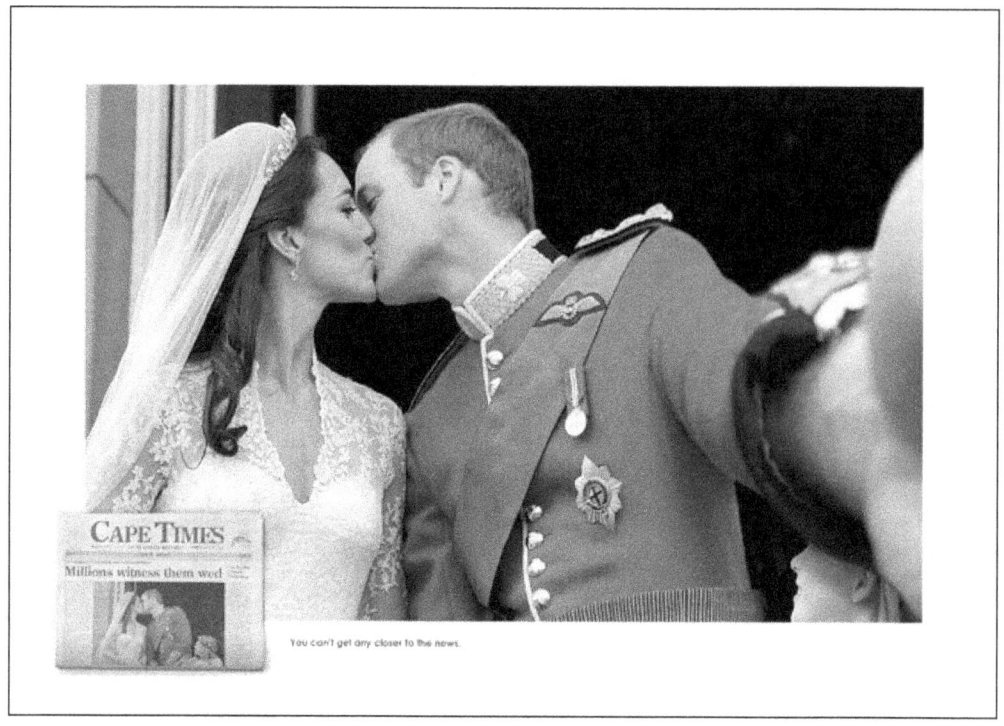

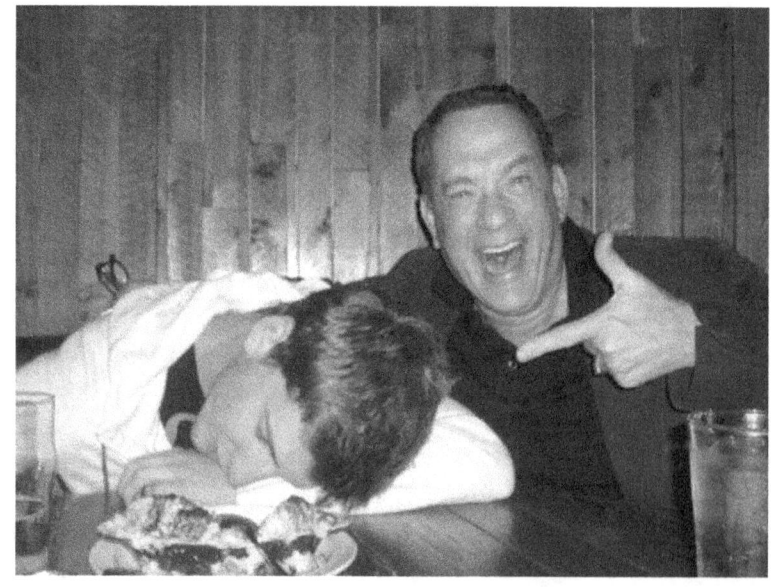

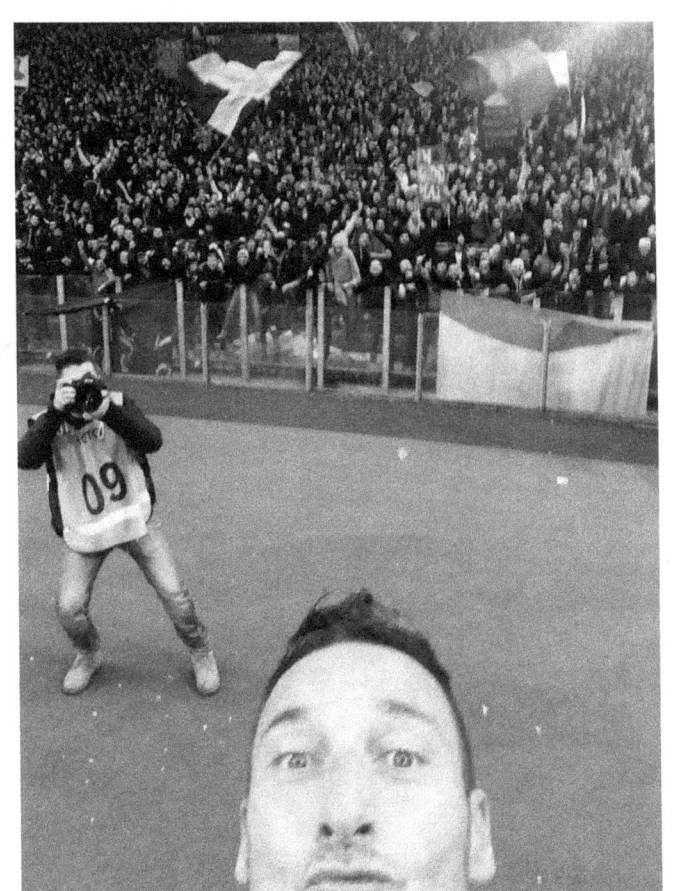

You can't get any closer to the news

Tom Hanks

Francesco Totti, January 2015

A COLLECTION OF TROPHY IMAGES IN MY COMPUTER

Just outta Hospital-Benzo and Xanax Withdrawal, 2015 png file

Ativan-Lorazepam withdrawal, everyday is horrible, 2015 png file

XANAX. Withdrawal-every day is a nightmare, 2015 png file

Même quand je te voyais tu me manquais encore, Amplepluis 2015

Être ami avec une hyène, Berlin 2014

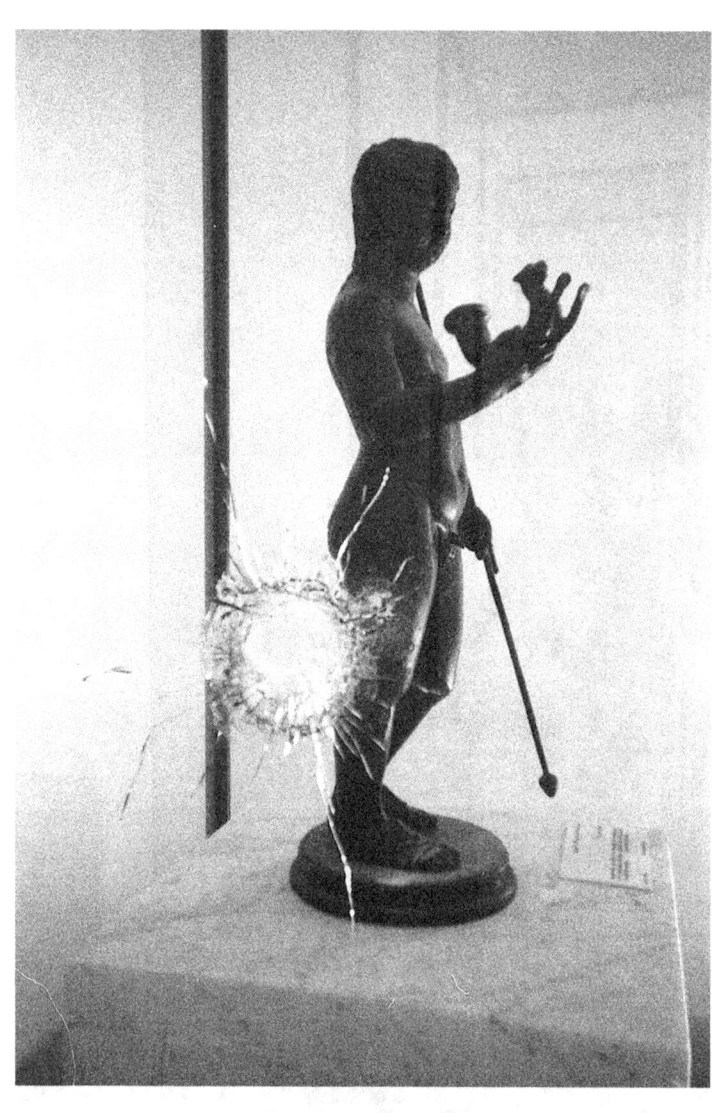

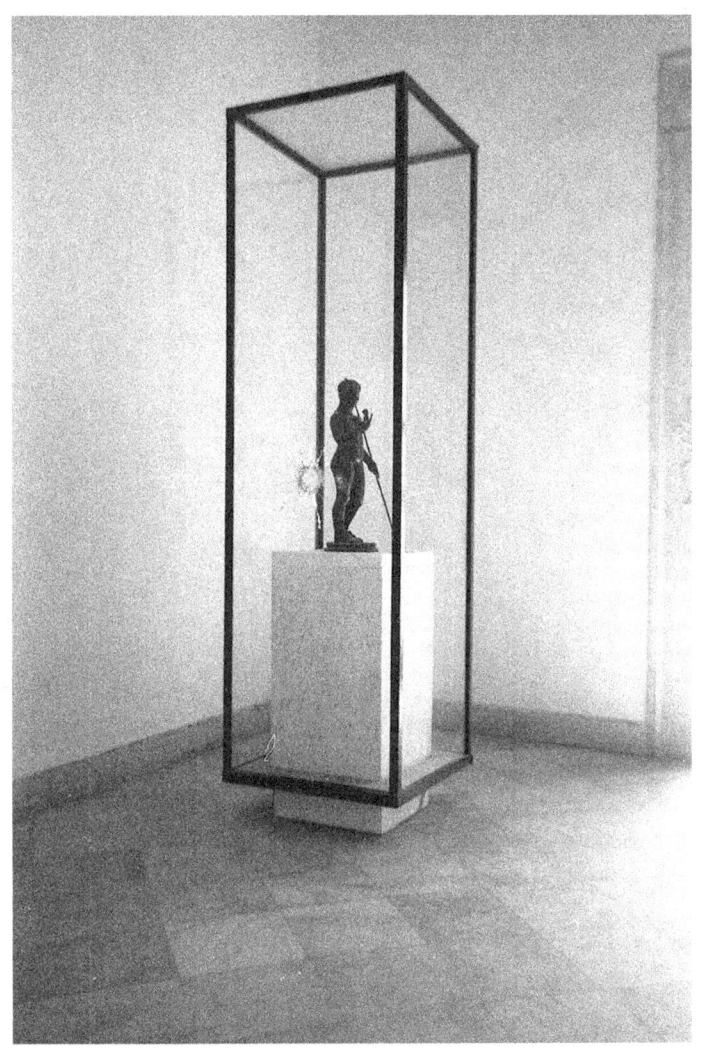

From the series *72 Days Later*, 2015

From the series *72 Days Later*, 2015

PHOTODUMP

148

IN MY COMPUTER #11

Not for Sale

Sales in Athens

PHOTODUMP

150

IN MY COMPUTER #11

Memento Mori

PHOTODUMP

152

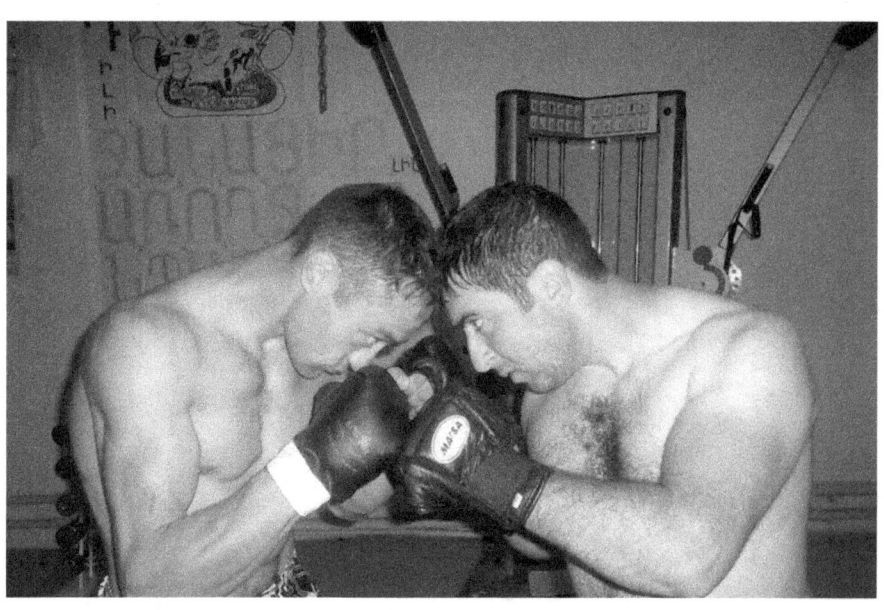

IN MY COMPUTER #11

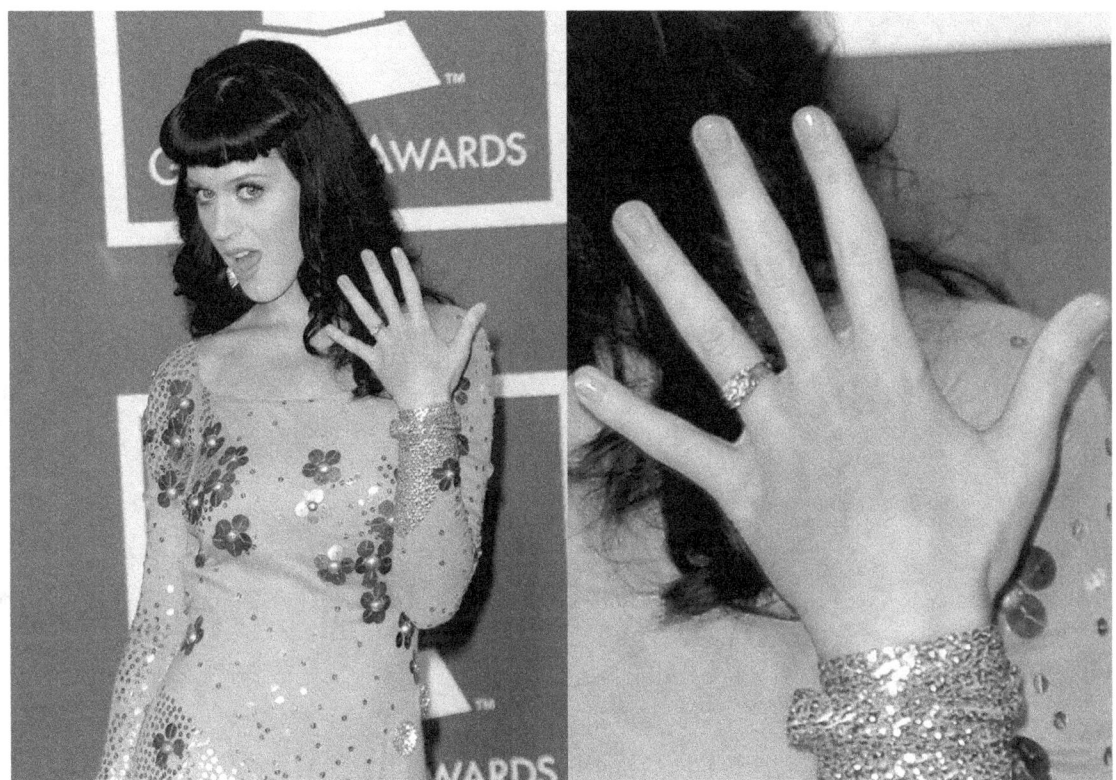

Armenian boxeur

Katy Perry is getting married

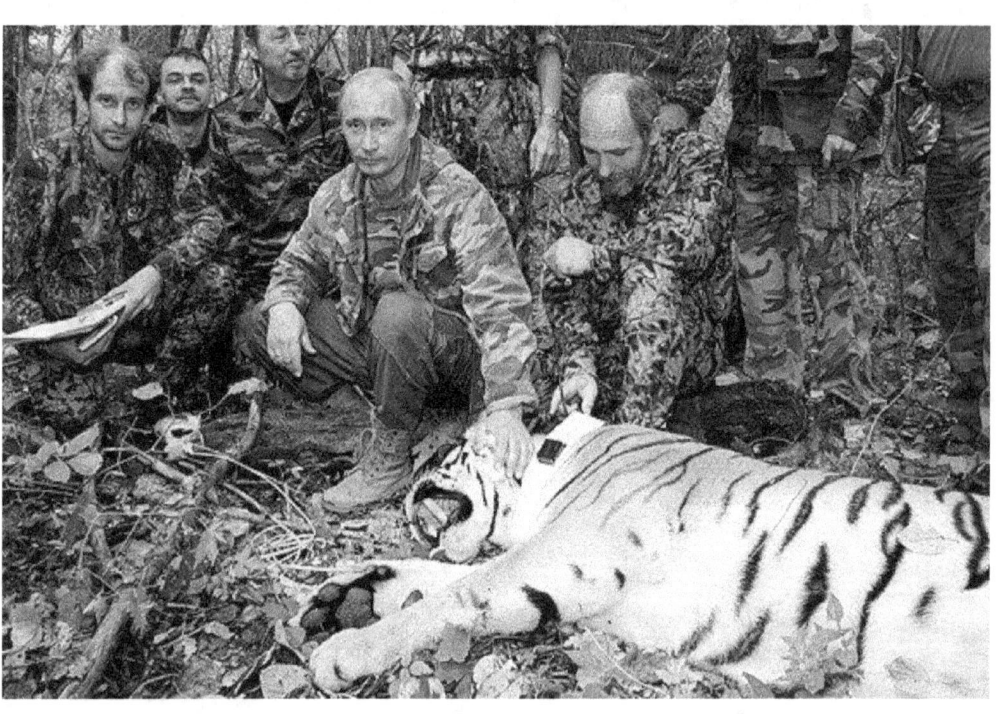

Vladimir Putin is seen in this undated file photo
tagging a Siberian Tiger while visiting the Barabash tiger reserve,
in eastern Siberia in the Amur Region of the Russian Federation

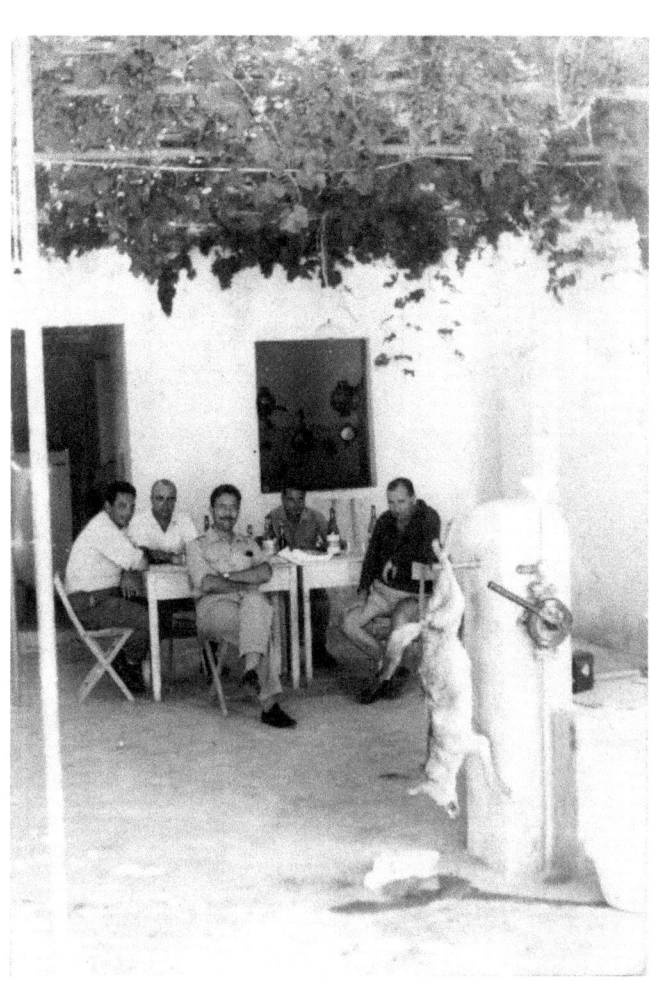

Mio nonno e lo sciacallo, Cirenaica, Libia, 1966

Selfie con Mu'ammar Gheddafi, Sirte, Libia, 2011

PHOTODUMP

158

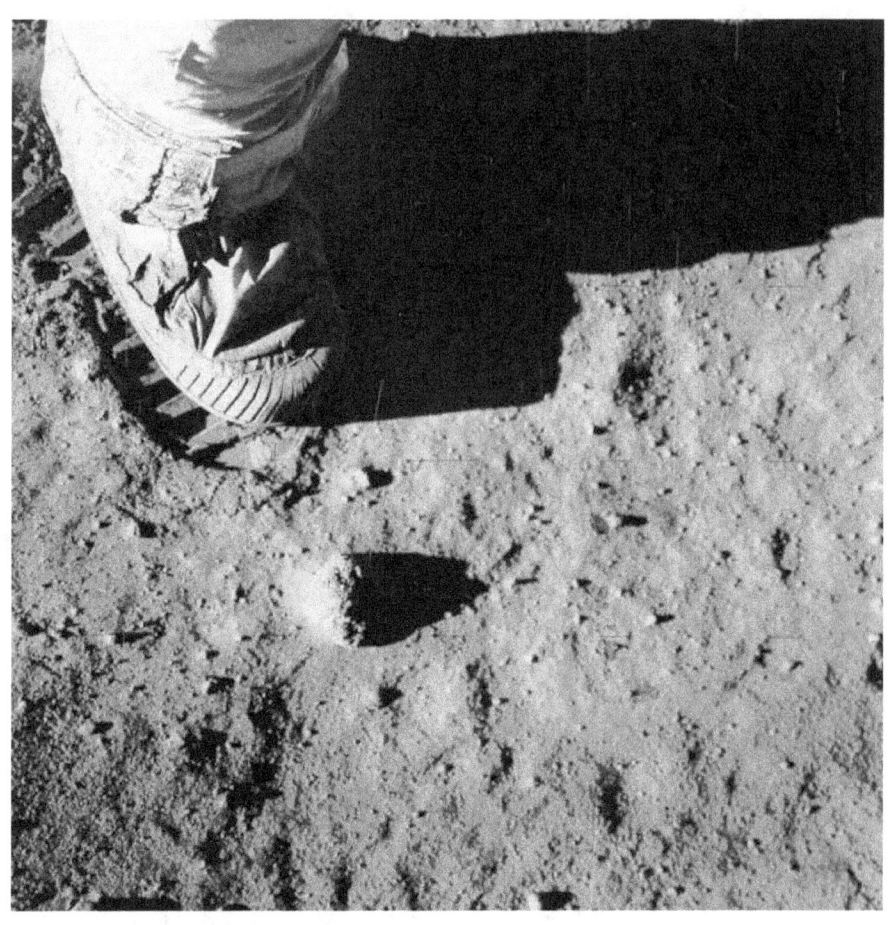

IN MY COMPUTER #11

Somewhere, July 20, 1969

PHOTODUMP

160

IN MY COMPUTER #11

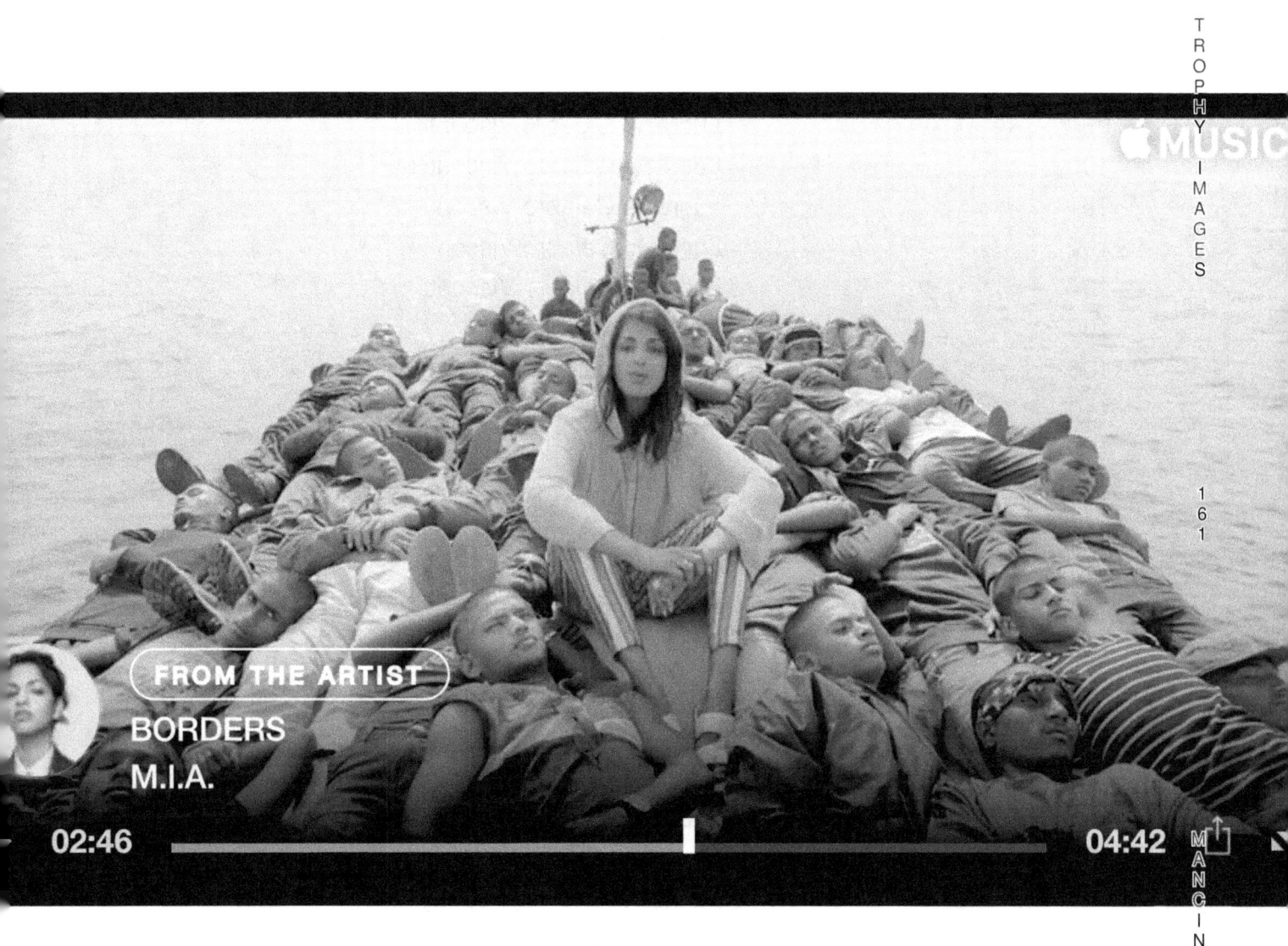

M.I.A., *Borders*, 2015

ICONOGRAPHIC INDEX

Pag.	Contributor
88	Valeria Mancinelli, Chiara Nuzzi, Stefania Rispoli
90	Leone Contini
92	Michael Dudeck
94	Elisa Adami
95	Elisa Adami
96	Guido Baccelli
98	Lucrezia Calabrò Visconti
99	Lucrezia Calabrò Visconti
100	Lucrezia Calabrò Visconti
101	Lucrezia Calabrò Visconti
102	Lucrezia Calabrò Visconti
104	Lucrezia Calabrò Visconti
106	Roberta da Soller
108	Curandi Katz
110	Curandi Katz
112	Nico Angiuli
114	Benedetta Falmi
116	Roberto Fassone
118	Roberto Fassone
120	Riccardo Fassone
122	Alessandra Ferrini
123	Alessandra Ferrini
124	Silvia Franceschini
125	Silvia Franceschini
126	Laura Lovatel
127	Laura Lovatel
128	Laura Lovatel
130	Elena Mazzi
132	Elena Mazzi
133	Elena Mazzi
134	Elena Mazzi
136	Elia Paoletti
138	Piter Perbellini
139	Piter Perbellini
140	Giacomo Raffaelli
141	Giacomo Raffaelli
142	Silvia Romanelli

143	Silvia Romanelli
144	Vladislav Shapovalov
145	Vladislav Shapovalov
146	Vladislav Shapovalov
147	Vladislav Shapovalov
148	Kelly Tsipni-Kolaza
149	Kelly Tsipni-Kolaza
150	Pierfabrizio Paradiso
152	Francesco Zaratin
153	Francesco Zaratin
154	Valeria Mancinelli, Chiara Nuzzi, Stefania Rispoli
156	Leone Contini
157	Leone Contini
158	Valeria Mancinelli, Chiara Nuzzi, Stefania Rispoli
160	Valeria Mancinelli, Chiara Nuzzi, Stefania Rispoli
161	Valeria Mancinelli, Chiara Nuzzi, Stefania Rispoli

Marta Ravasi

Paradise Parade

I	p. 166	VI	p. 196
II	p. 172	VII	p. 202
III	p. 178	VIII	p. 212
IV	p. 184	IX	p. 220
V	p. 190	X	p. 226

I

There are an interior and an exterior. When I think about art I try to identify something indefinable that could be placed between the two, something that is in-between, a film that equally adheres to both the positive and the negative of reality, one that does not separate but rather covers both.

Art is always, in an indirect and subtle way, a representation: of both my interior* and our exterior, by which we mean the personal and subjective, and the matter-of-fact reality of things that involves us all.

Interior and exterior are the concave and the convex of the great dilemma, which the process called representation, tunnels through. I want to define this process with this term, representation — even though I am aware that it could be easily substituted with the word art.

* The interior perhaps, is not so subjective, as it may be demonstrated by the history of art that always identifies the same content (the fruit of this very interior), regardless of the individuals who produce it. As such, it is unchanging in time and in means.

This might be an attempt to define something with no explanation nor proof, but what is understood is that the unutterable message X is expressed in many ways and through many languages.

PARADISE PARADE

167

RAVASI

PHOTODUMP

168

IN MY COMPUTER #11

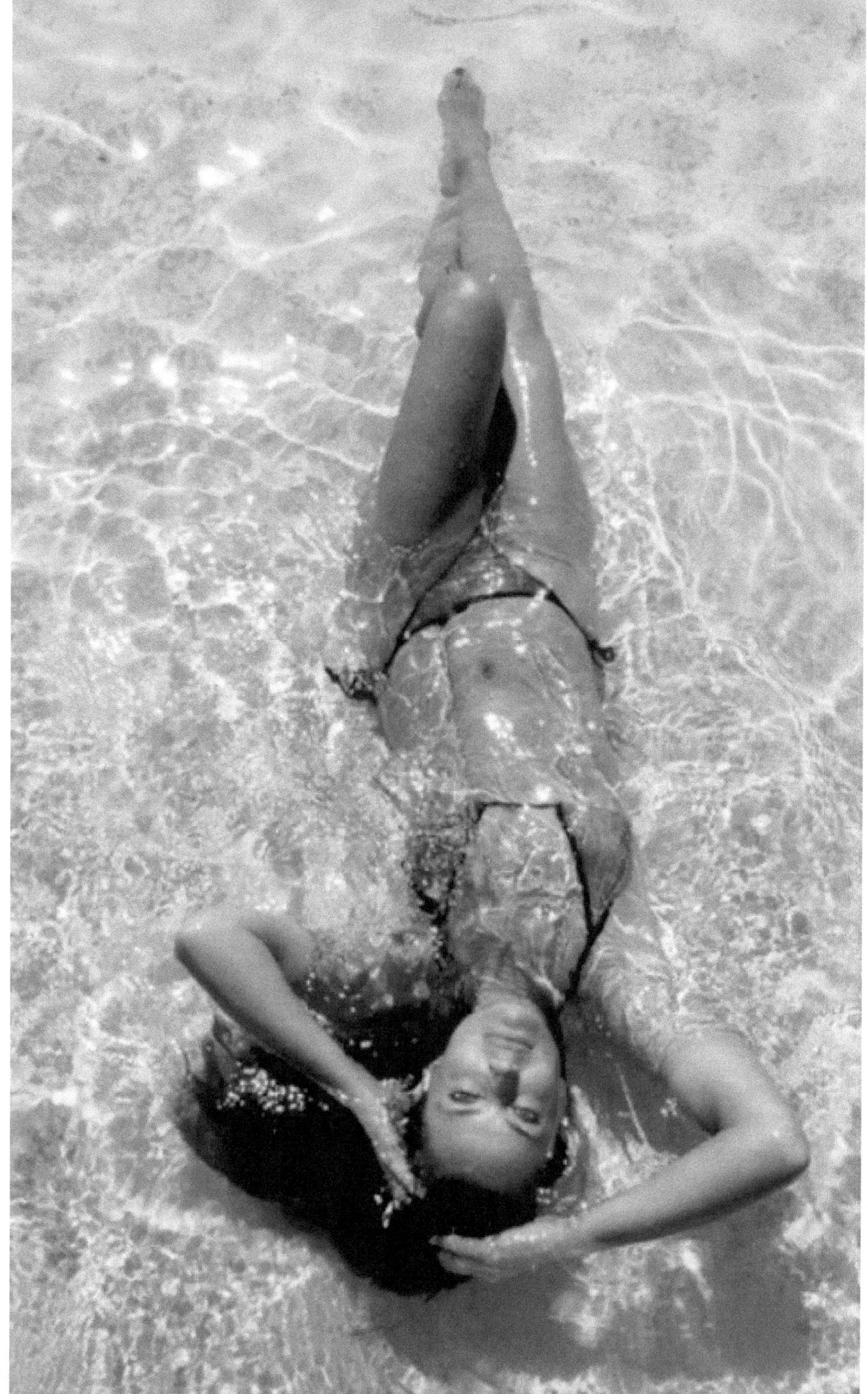

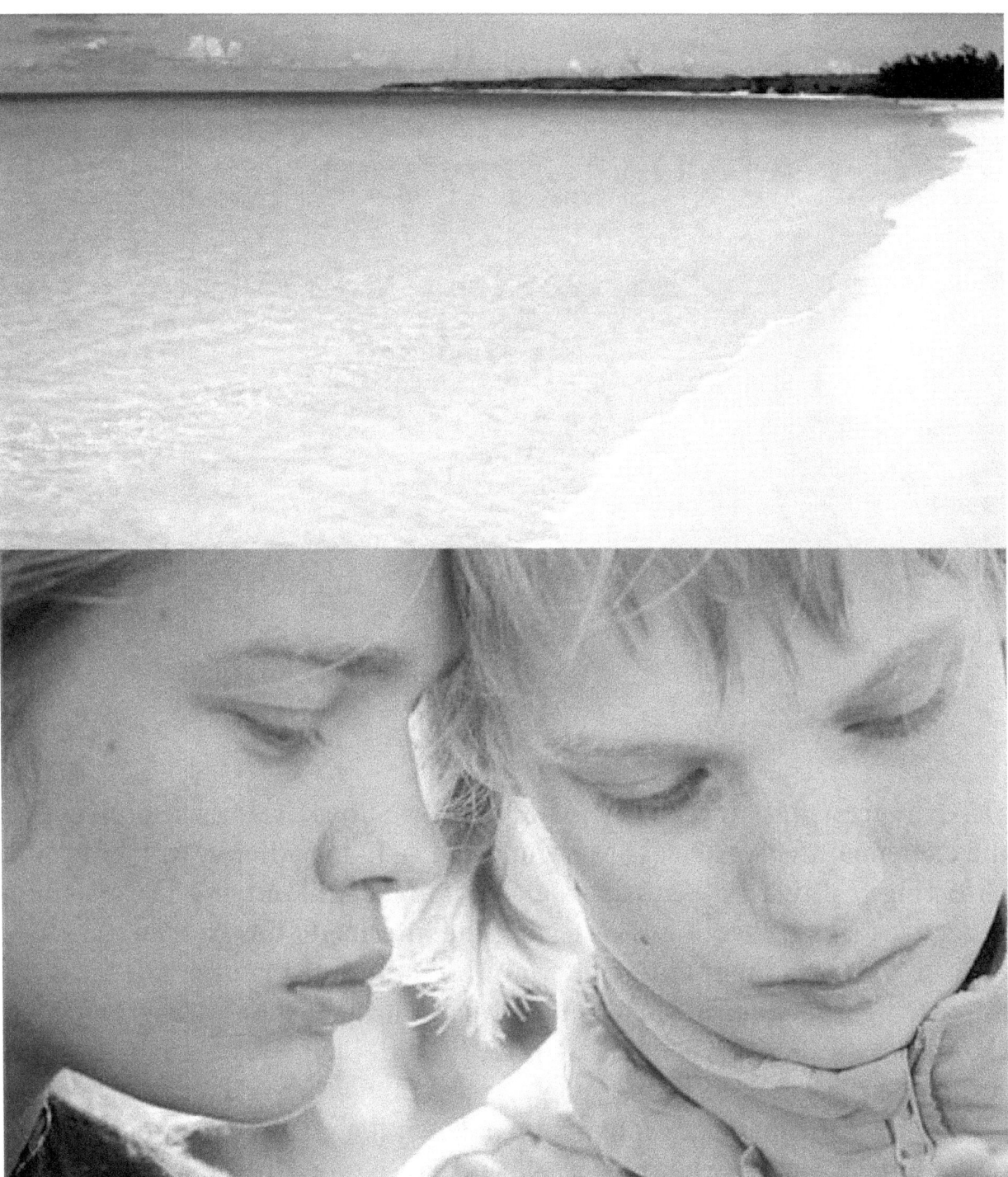

III

Art, or representation perhaps, as previously defined, is always connected to the contemporary world of those who produce it and who, by watching and observing reality are able to appropriate it and distill out of it the essence of a collective feeling, therefore connecting the interior to the exterior.

This is the infinite material which the artist manipulates. His is a practice that develops in various ways and that takes shape and grows and is channeled through many languages. Yet they all identify the same images, or rather ideas, as defined by the Jungian term imago.

If the message remains unchanged, the means do change according to the times. "Societies have always been shaped more by the nature of the media by which men communicate than by the content of the communication." It is with this sentence from Marshall McLuhan's *The Medium is the Massage* (1967) that this argument proceeds, and it is linked to the analysis of contemporary communication and the exchange of information — visual information, i.e. images, in particular.

PARADISE PARADE

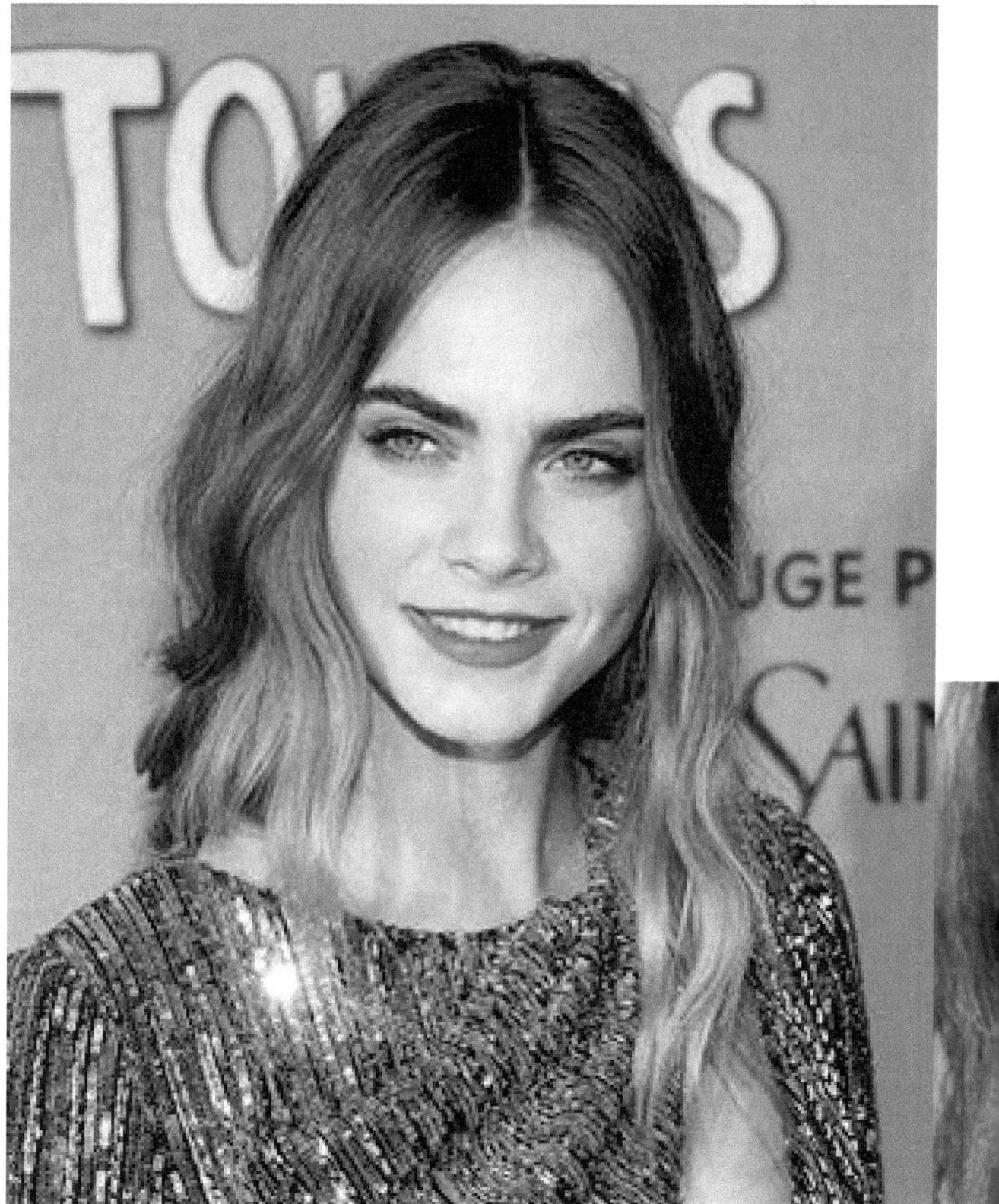

PHOTODUMP

176

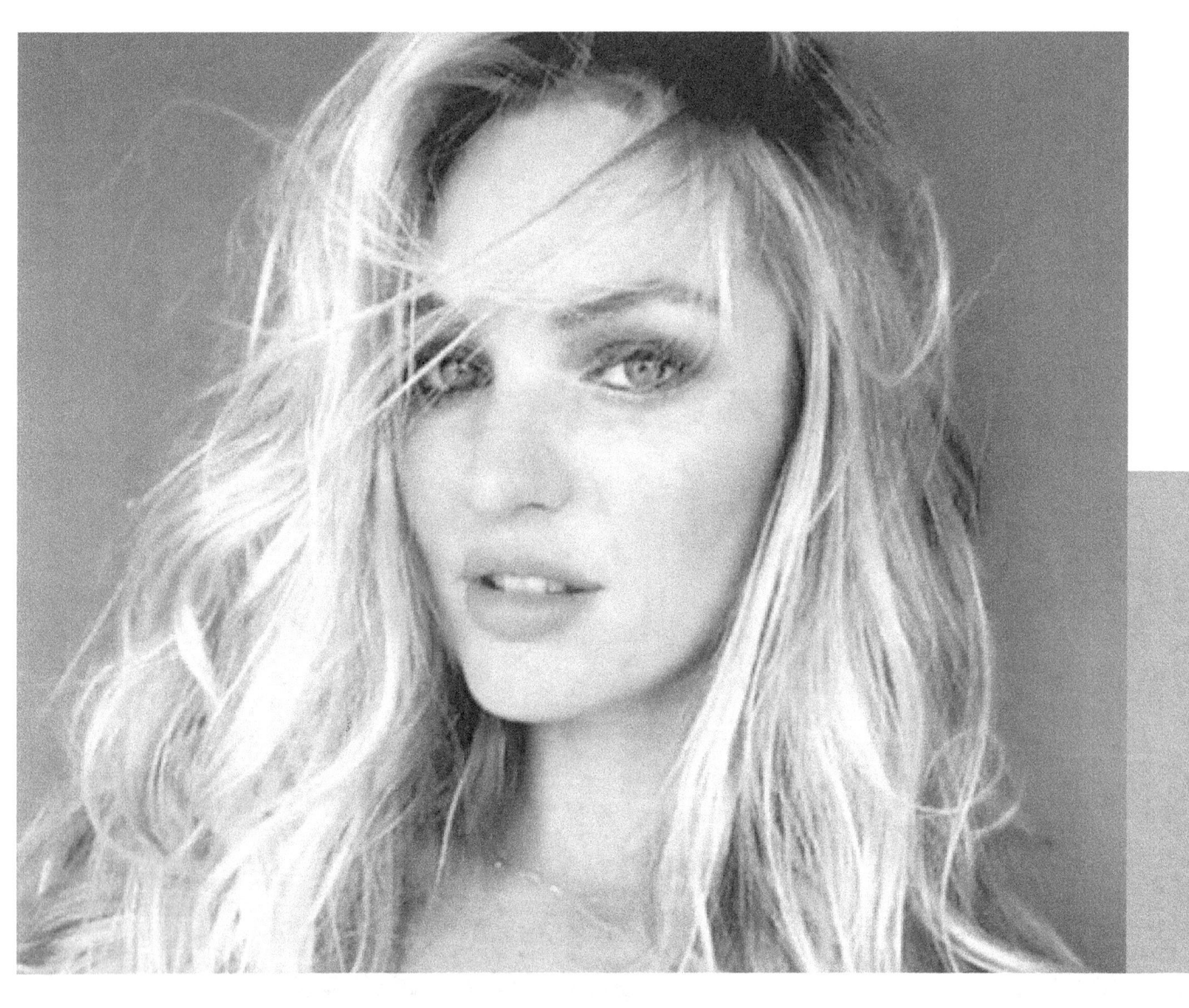

IN MY COMPUTER #11

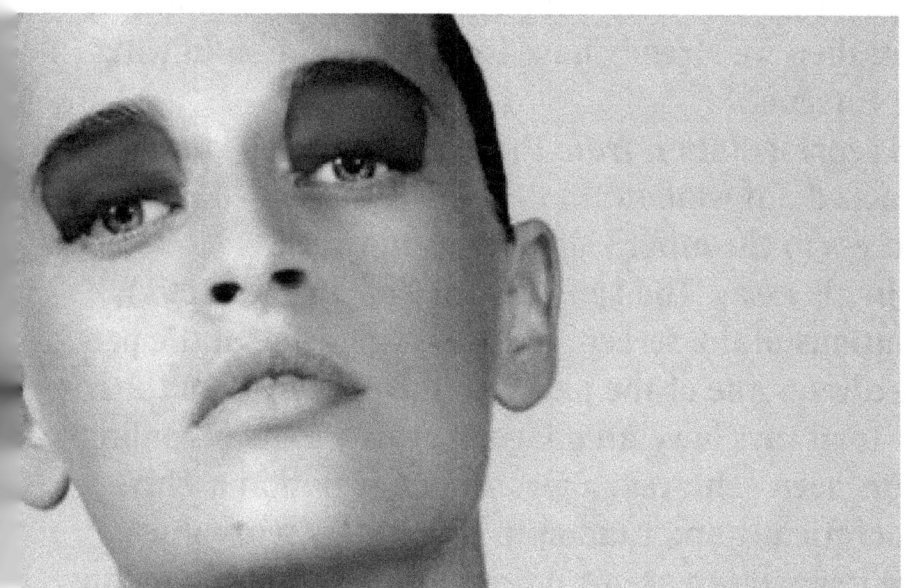

IIII

If reality is progressive and it happens chronologically with the becoming of the future into the present, then we already have its representation in what occurs in real time on the Internet.

We witness this representation from the other side of the barrier that we call monitor: a blacked out window. In this sense, the screen is at once a limit and the point of access to the other side of the shipwreck.

Lev Manovich, in his essay 'The Language of New Media' (2001), identifies the various evolutions of the screen, from the static one of the permanent image — which is always one of the past into the present — to the real-time screen that allows to always have an image of reality in its becoming.

A utopia has thus been achieved: a gigantic information archive that can be accessed democratically and randomly. It is in this sense that "every object has the same importance as any other and everything is or can be connected to everything else."

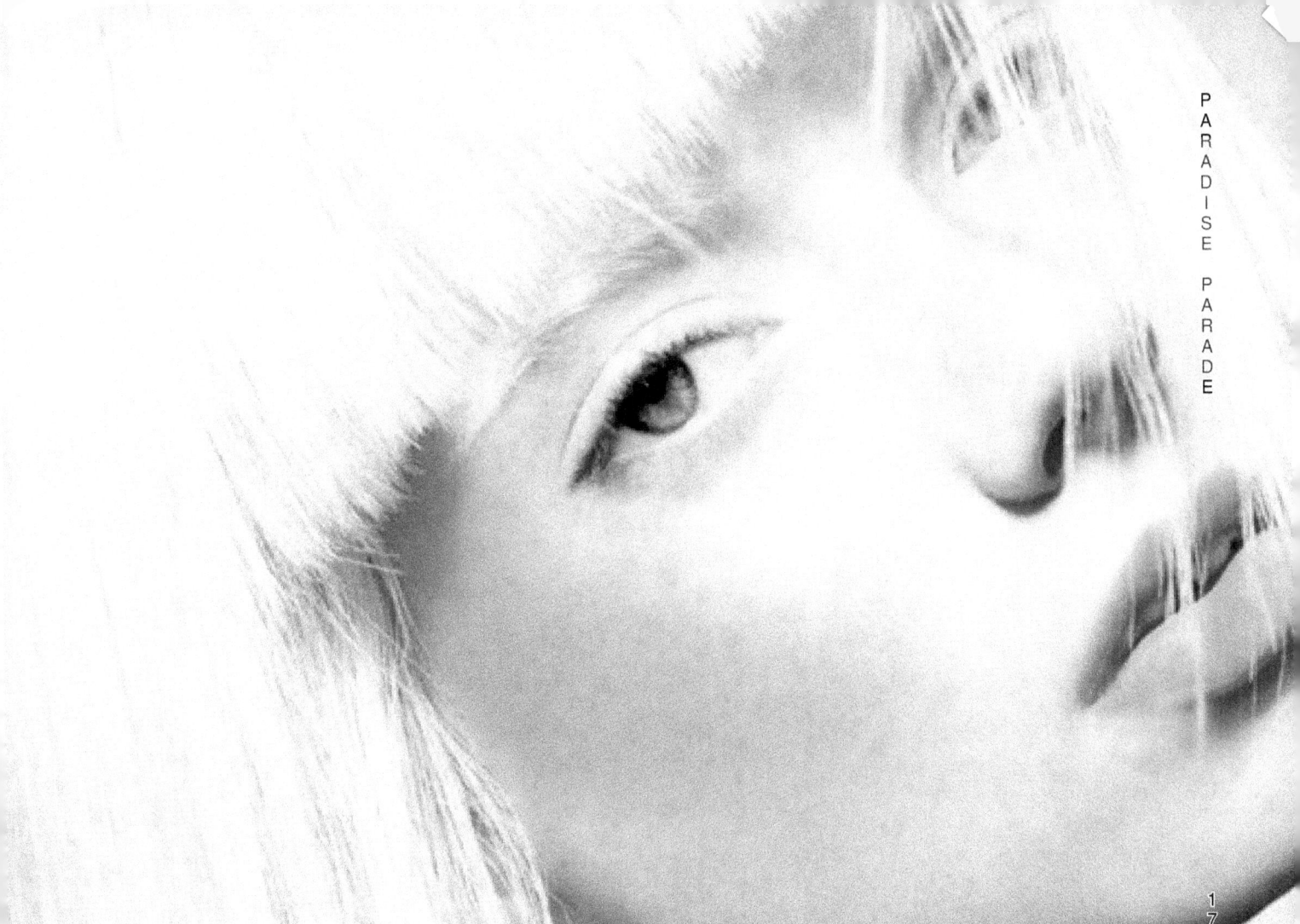

PHOTODUMP

180

IN MY COMPUTER #11

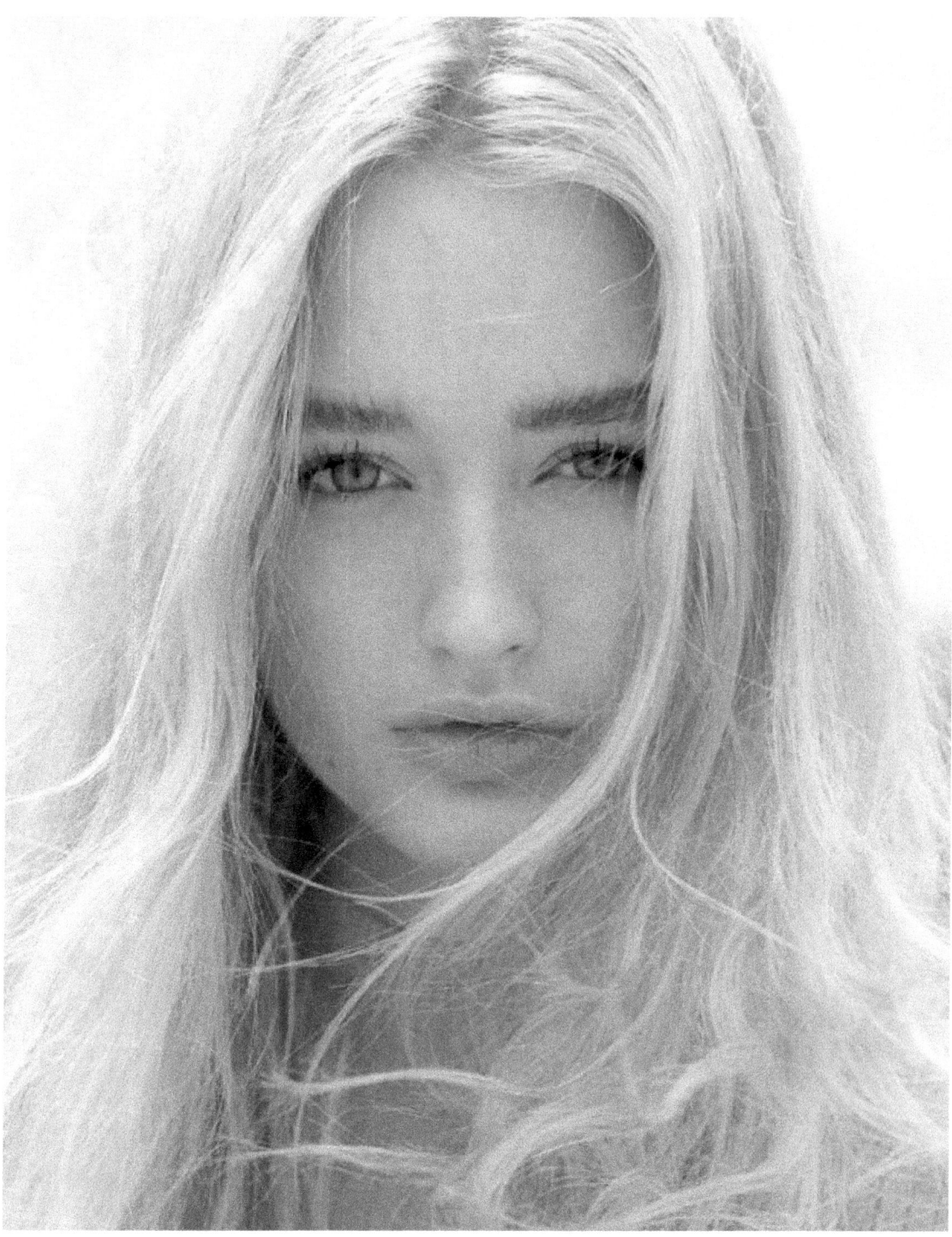

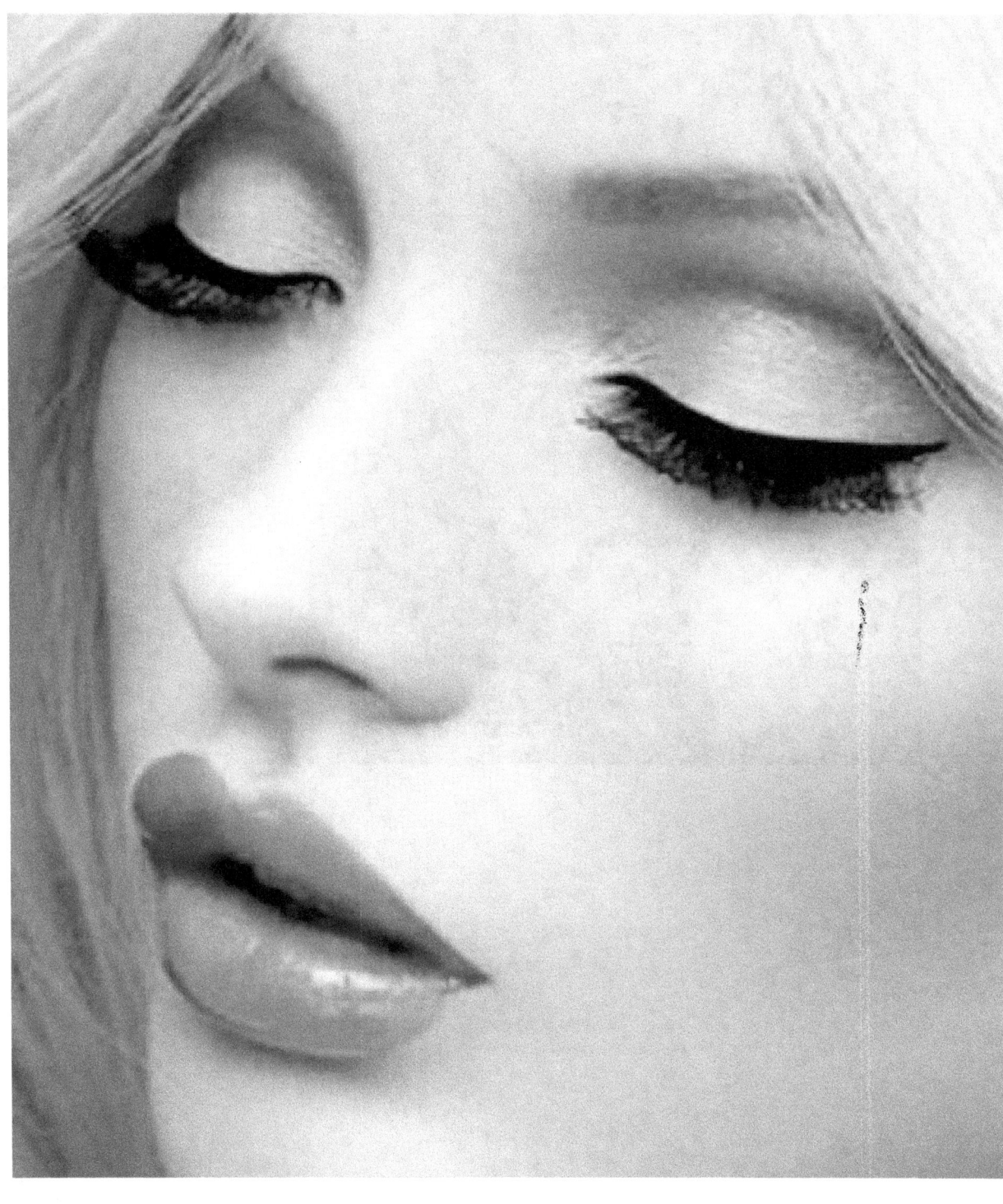

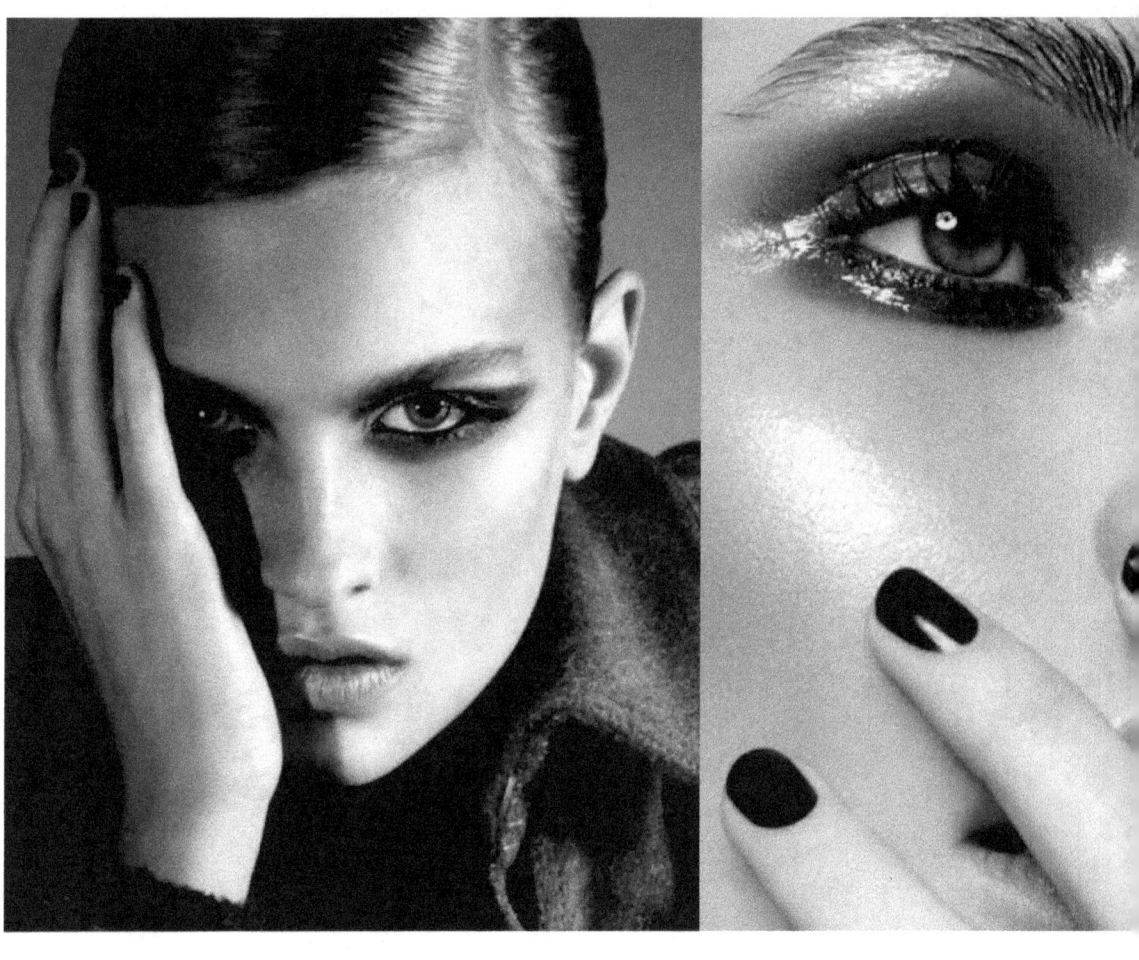

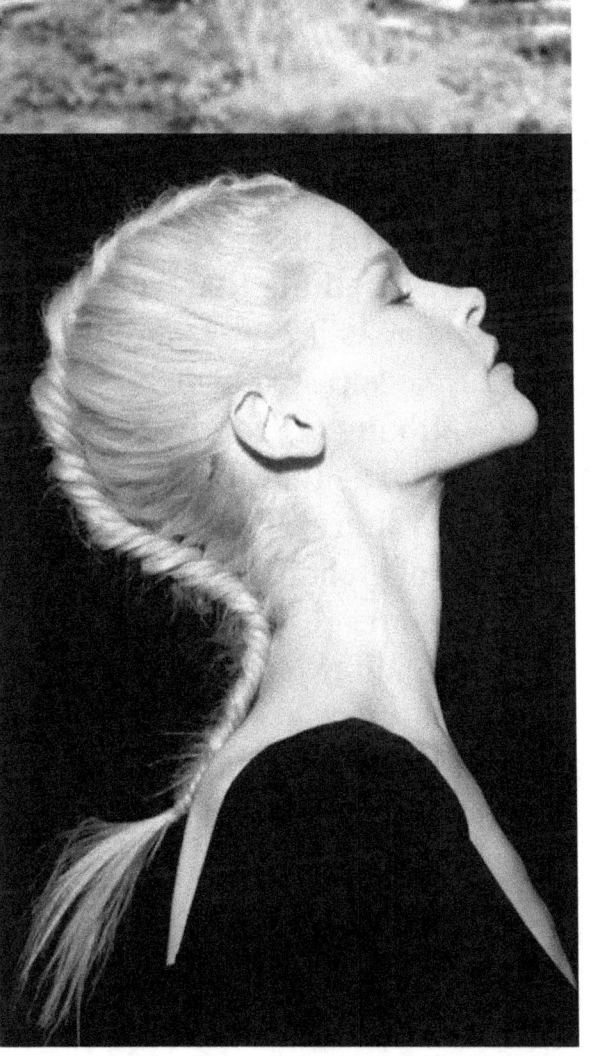

IV

Beyond the screen, a sprawling spectacle. A blend of areas made up of data directly produced by three factors: consumer culture, the present/news and personal content. The result is a panorama stretching between a positive end of desire for something that we do not have, and a negative end of images of terror and fear. As if it were an autonomous collective unconscious, which could solely be accessed by privately using social networks.

Although this private access allows a partial view of the virtual reality, it is also true that this is a common resource accessible by all. We share it — where 'to share' gains a new meaning. And if the Internet is the most important sign of globalisation, then maybe representation is no longer the fate of the West alone.

Recalling McLuhan's prophesying of the advent of the global village, both time and space are here called into question: "We now live in a global village, a simultaneous happening. We are back in acoustic space."

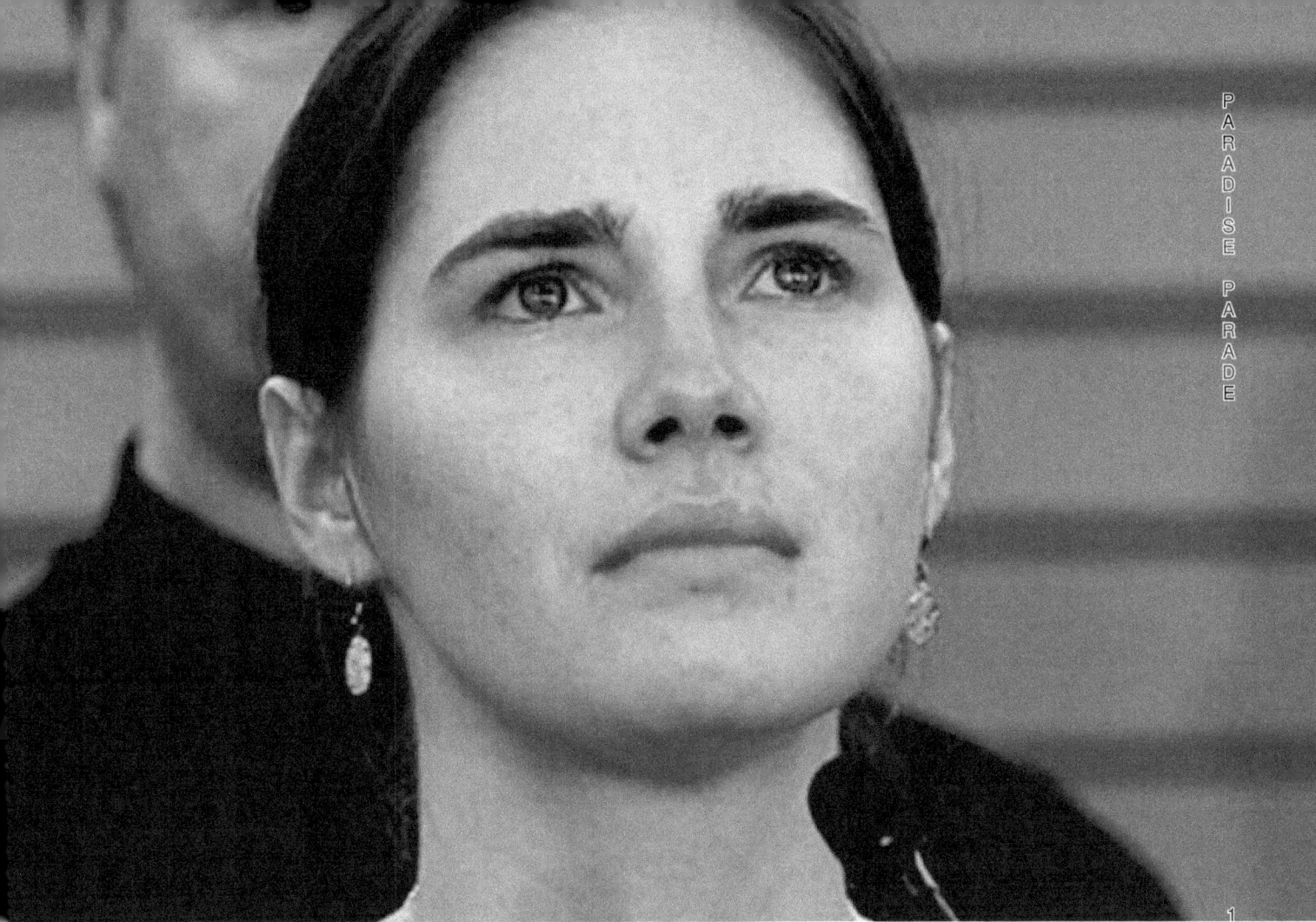

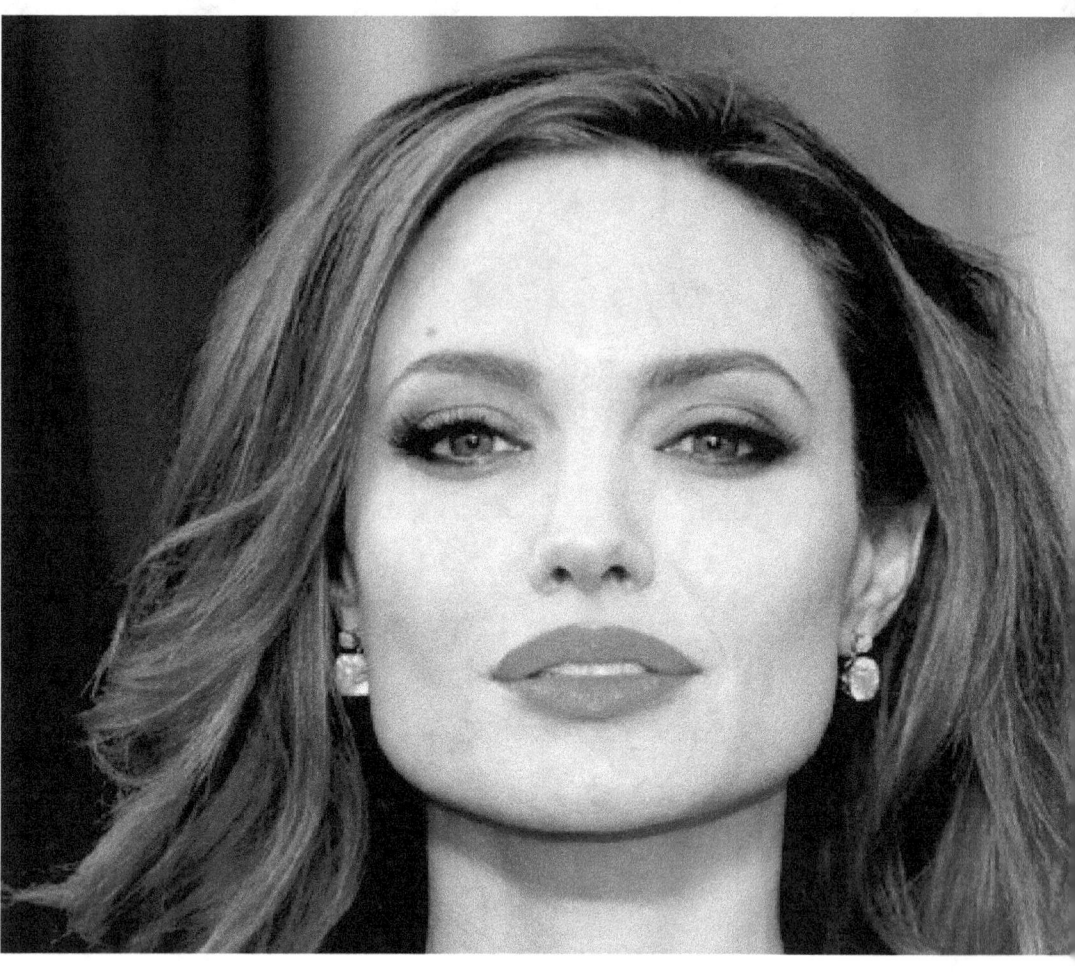

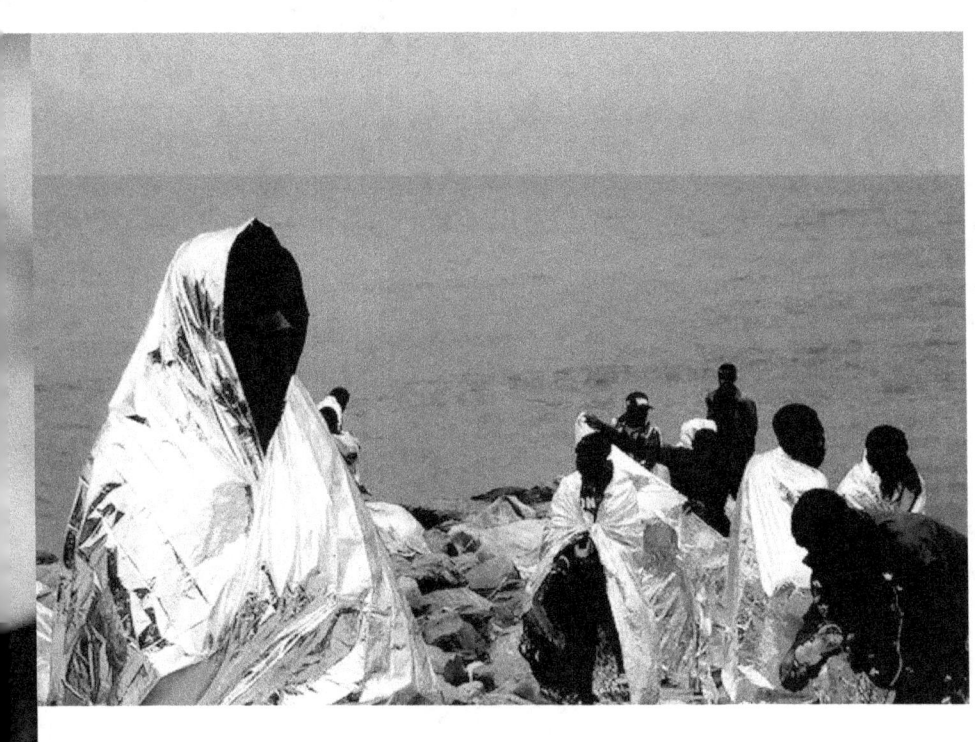

PHOTODUMP

188

IN MY COMPUTER #11

VI

Arguably, the Internet shows a constantly updated, and presumably most faithful, image of reality - one that presents itself in infinite copies on infinite levels. Perception however remains relative to the individual, even when its mechanisms are changed.

In this respect, the references here are necessarily personal. Cue my memories of the screen, using television as the example:

1 My earliest encounter with death when I watch a TV documentary on African tribesmen building caskets shaped like animals and things (I vividly remember rooster, fish, guitar)
2 An apocalyptic feeling when one summer evening I learn of Lady Diana's death shortly followed by the news of the death of Mother Teresa. Watching on live TV the funeral of the former while having lunch at an elementary school mate's house. We ate breaded cutlets.
3 When at home alone I witness the collapse of the Twin Towers.

Today I know that the custom caskets are built in Ghana and are called Fantasy Coffins, that both women were and still are two icons, and that 9/11 is a date that has shaped history.

PARADISE PARADE

PHOTODUMP

198

IN MY COMPUTER #11

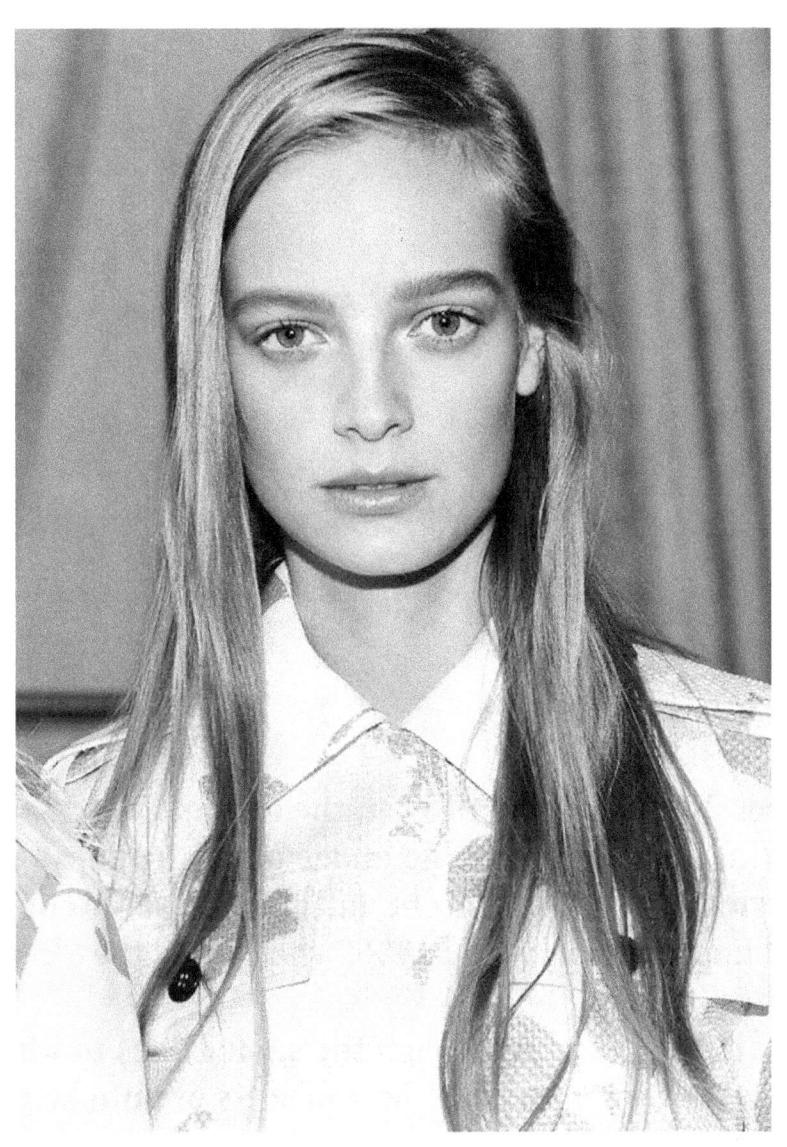

PARADISE PARADE

201

RAVASI

On 11 September 2001, the fallen Tower, the one and only Babel, was replaced by these two twins. The unforgettable image of that collapse was not merely fixed in the single moment of an event, but it has forever changed the iconography just as it happened on 5 July 1996, when Dolly the Sheep became the sacrificial lamb.

 Certain images emerge from the same chaos to which they are destined, by means of what seems to be a process of auto-selection, but is instead steered by the collective unconscious. Iconography, in this sense, is an ever-expanding fluid structure that moves from its history onto the path of the present, accommodating the new images to the long-standing ones. There are still Rafts of the Medusa and Madonnas with Child, I believe that the colour of luxury is still azure, today known as Tiffany Blue – RGB (10,186,181) – CMYK (74,5,38,0) – HSV (178°, 95%, 73%) and that orange may be the colour of fear.

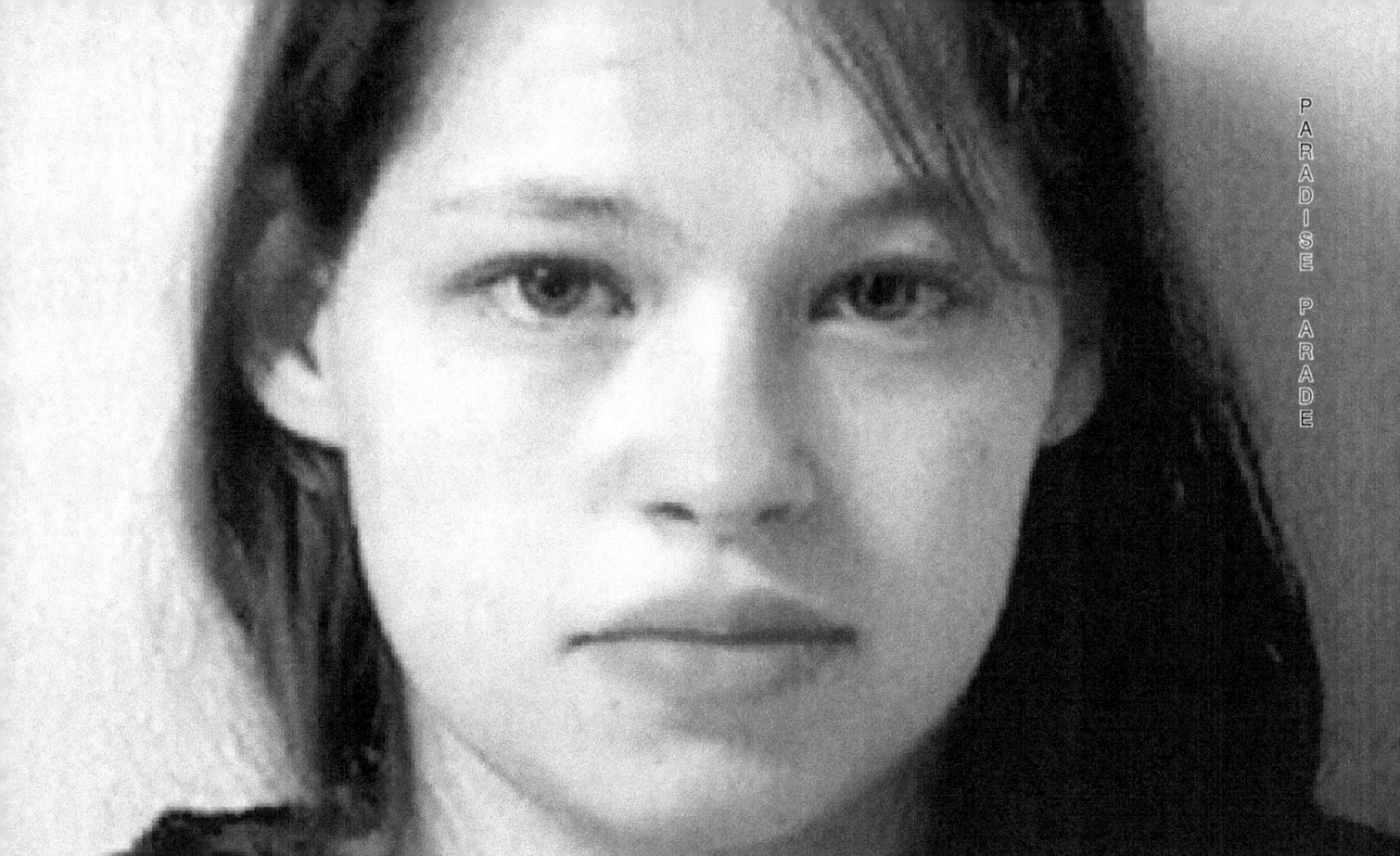

PHOTODUMP

2004

IN MY COMPUTER #11

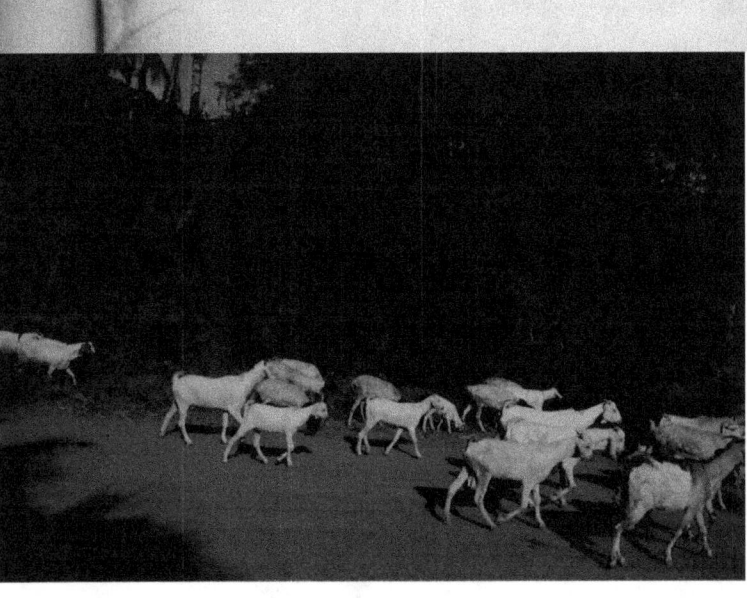

PARADISE PARADE

205

RAVASI

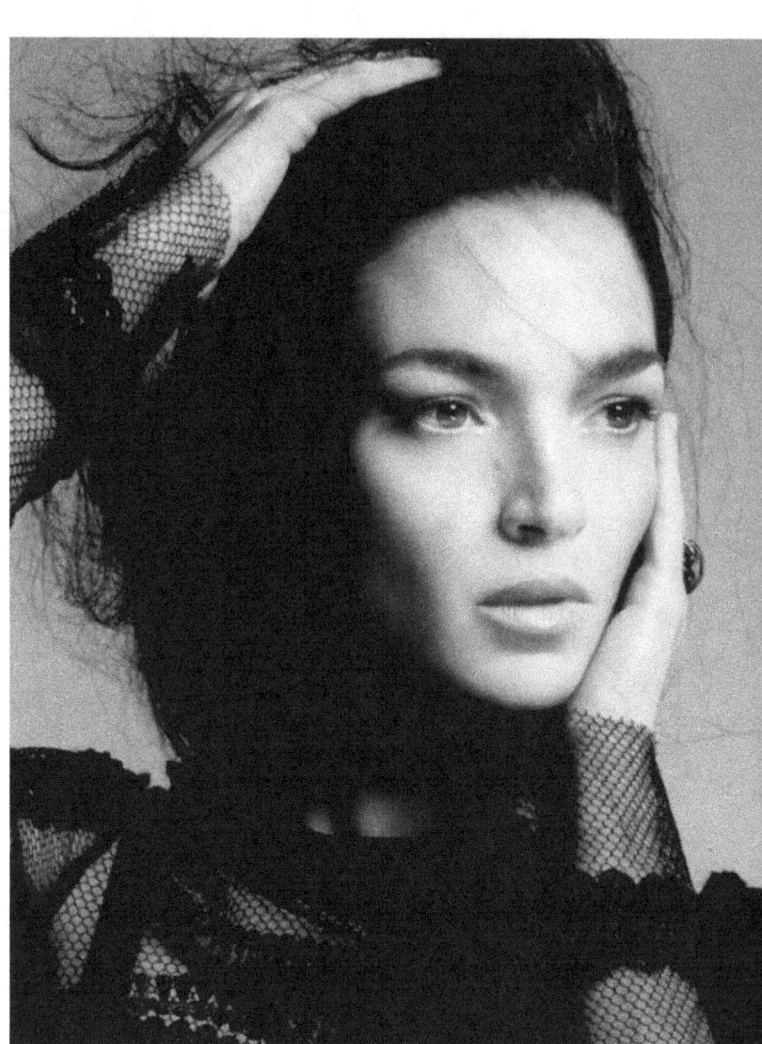

PHOTODUMP

206

IN MY COMPUTER #11

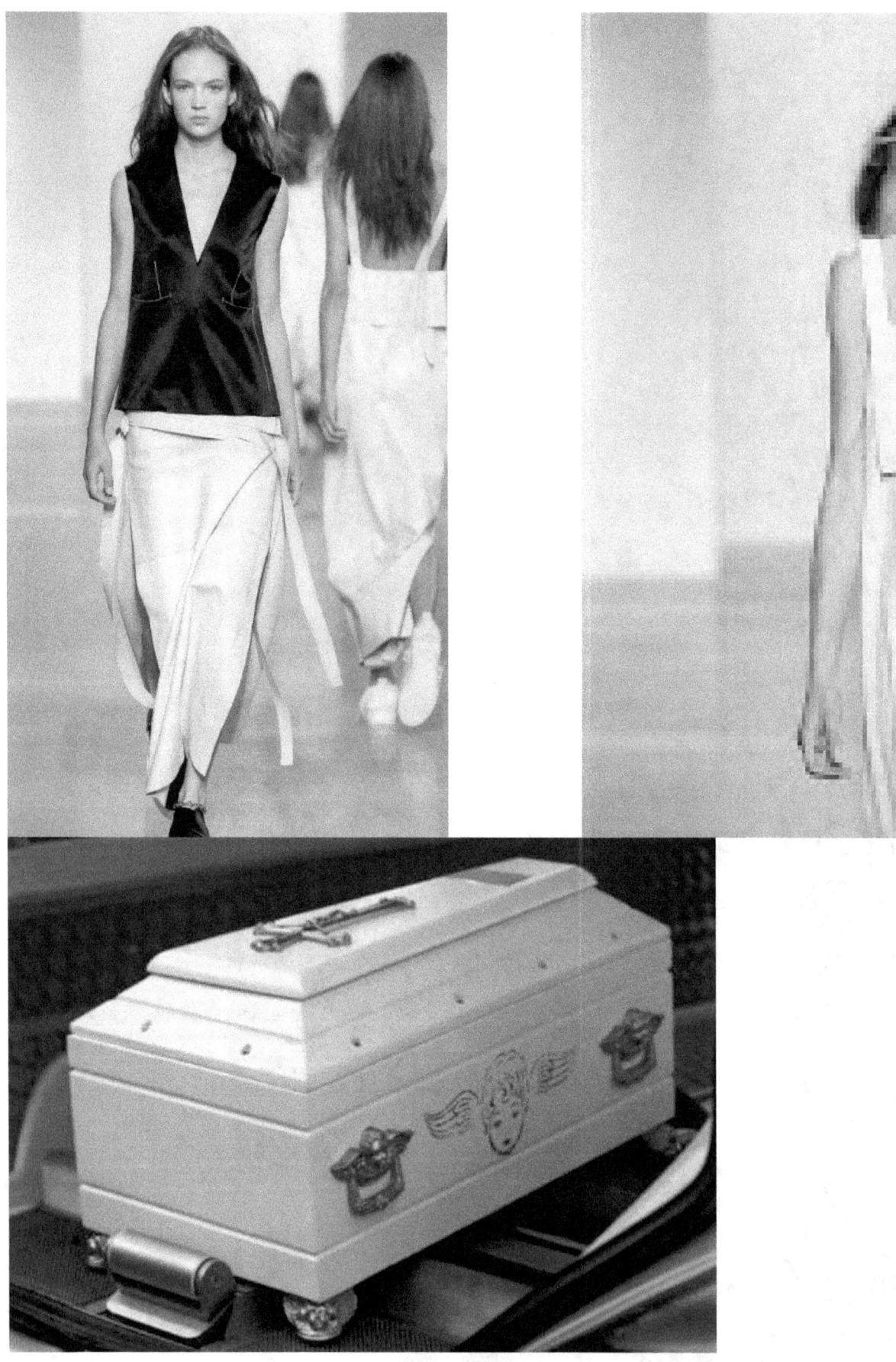

VIII

To remove an image from the chaos to which it is destined is an act of salvation; recognizing and ascribing new and unexpected meaning are its necessary conditions.

By asserting themselves, new images expand iconography. An analogous selection mechanism can be observed in individual action: Cut and paste are optimal instruments, at once actions and tools that allow to make the selection process direct. Personal conscience and its desire for appropriation refine this process. Here I speak of those images that have been saved from the Internet and piled up in abandoned collections, once opened and now forgotten in some cluttered corner of our server. News, consumer culture and personal images are fetishes of desire — for love or for death. After every plunge, to re-emerge from the Internet with a handful of images is to search for signs, asking for advice from this new oracle.

PHOTODUMP

214

IN MY COMPUTER #11

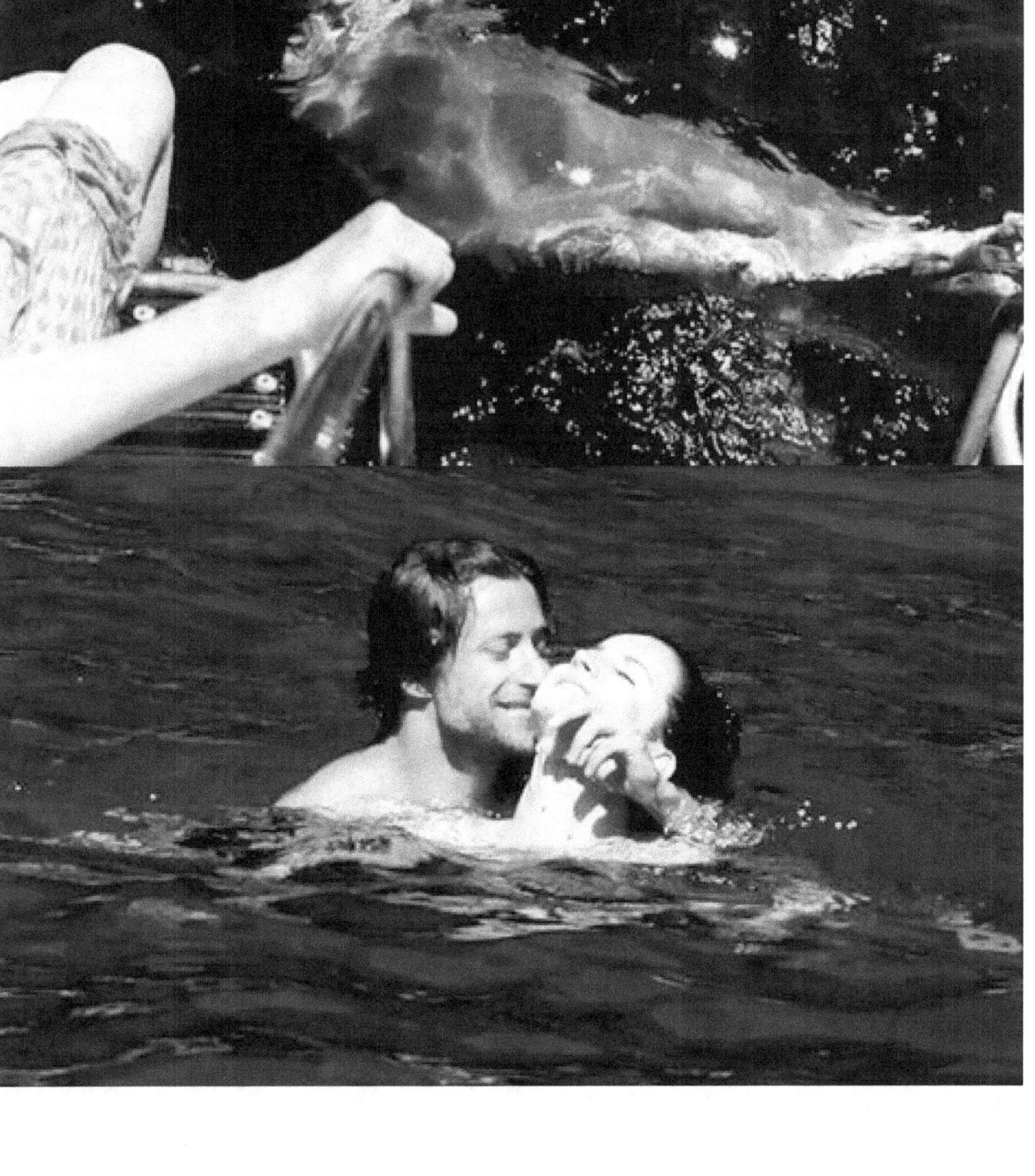

PHOTODUMP

216

IN MY COMPUTER #11

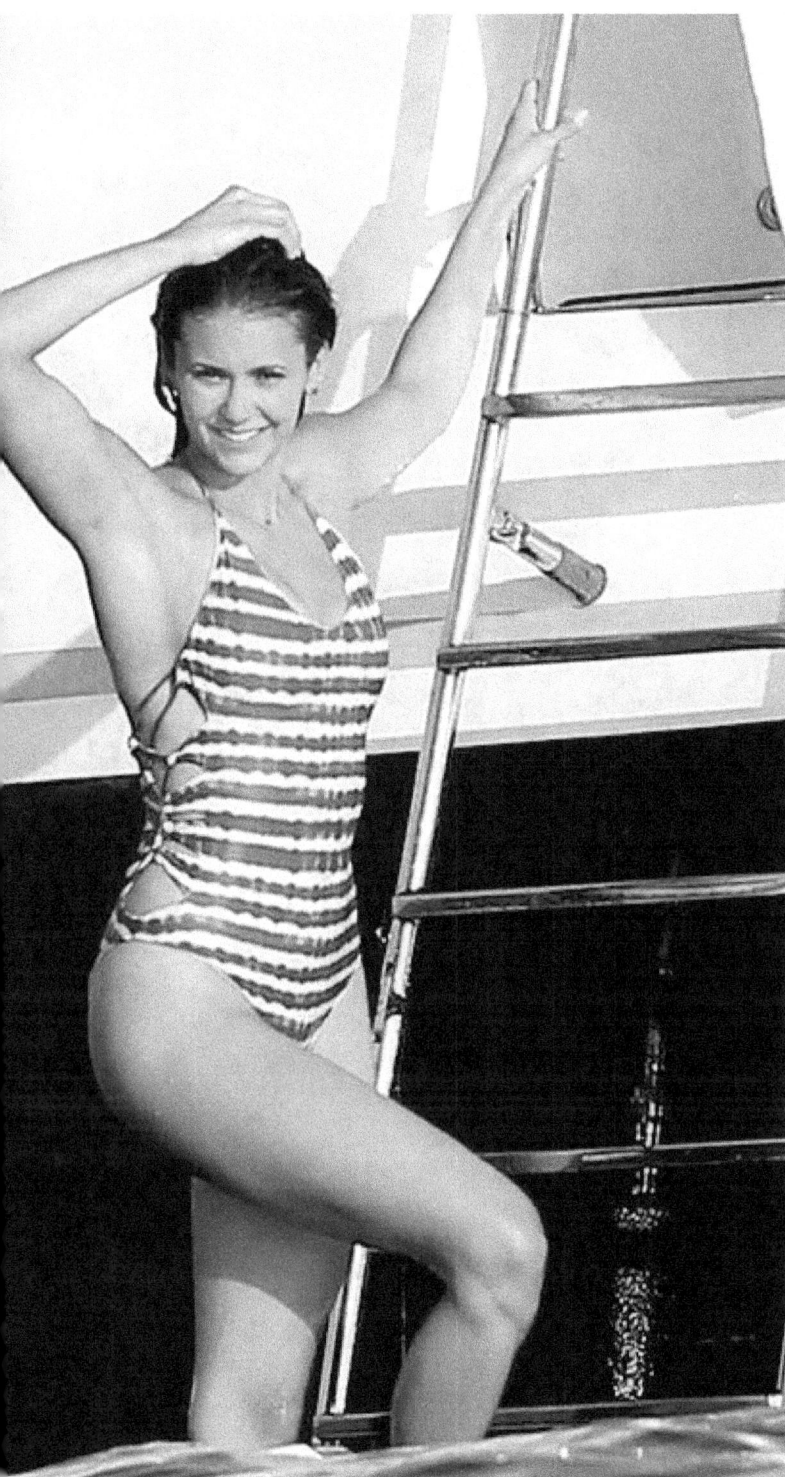

PARADISE PARADE

219

RAVASI

Image choice, selection and organisation can therefore be considered both as part of the creative process supporting other practices, and as an independent attitude. I will consider this choice according to the latter point. This rescuing deed is nothing but a primary compulsive action, and its end product is not an archive, but rather a collection in a state of becoming.

 Whereas the archive's structure is closed and clearly defined, the collection's is only relative to the collector, who determines its rules and keeps them flexible. It is in this sense that I define this assemblage as a dynamic — and not necessarily sequentially or narratively arranged — set of images. Open and expandable structure in which all objects are related to each other, and each one of them is indispensable. Varied yet interchangeable units combined, resulting in a work that is prime and unique and that is a glance. Defined according to these parameters, the collection of which I speak follows the same rules as the Internet, and is at once reflection and distilled essence.

PHOTODUMP

222

IN MY COMPUTER #11

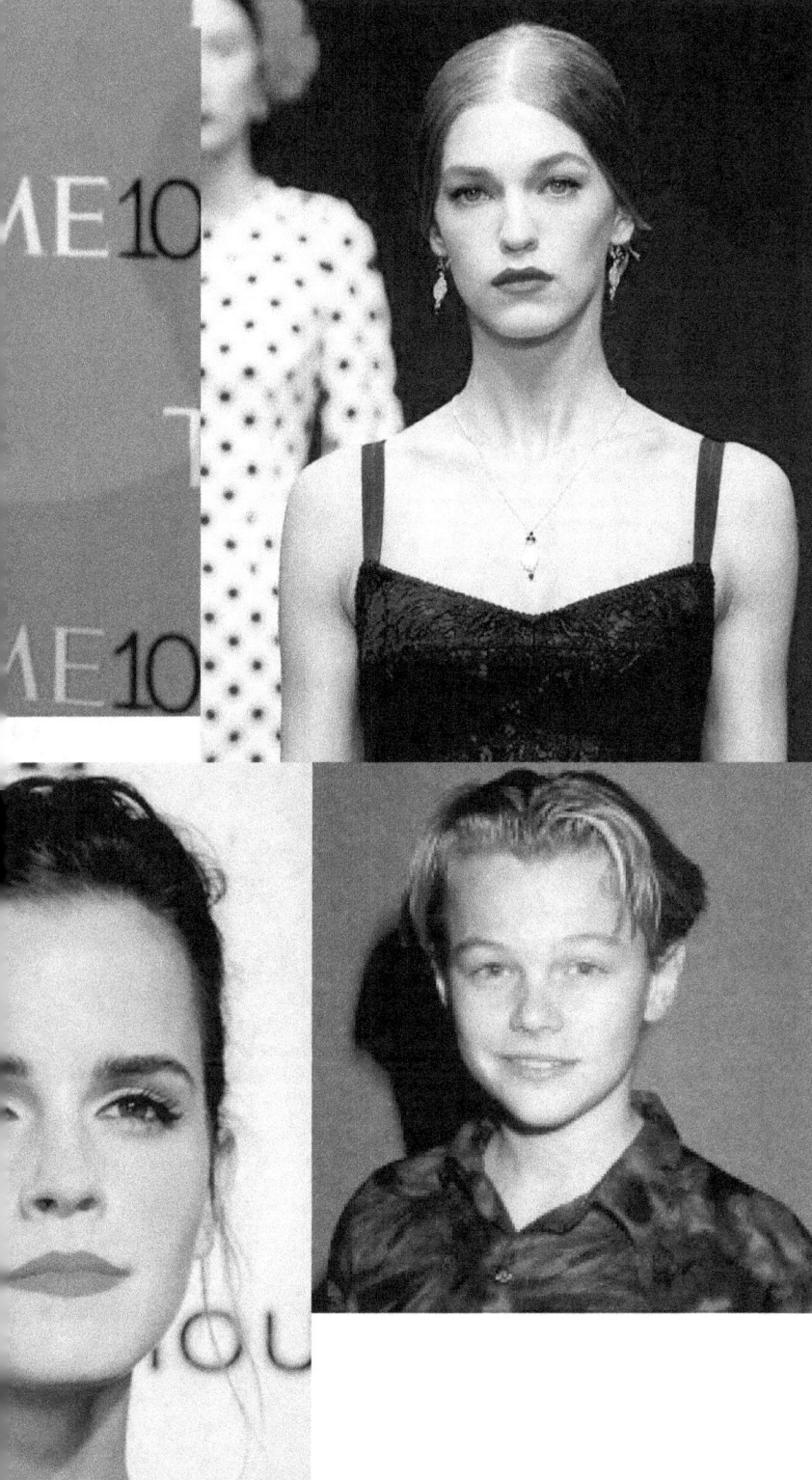

PHOTODUMP

224

IN MY COMPUTER #11

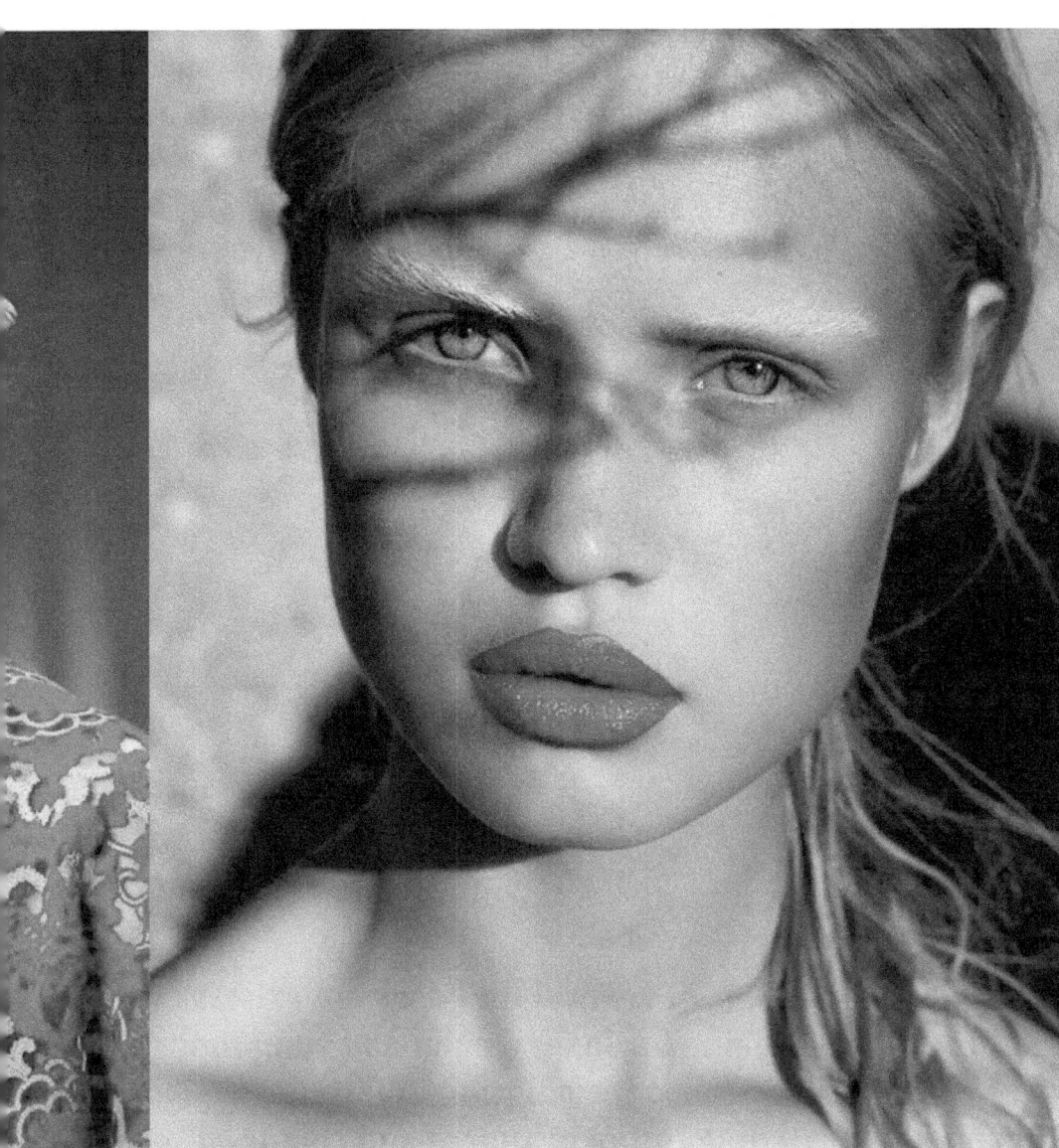

This collection is my own private tale of a world that does not exist, as viewed through the world that I see. A longing for luxury, calm and voluptuousness. It is a march on paradise. In these files, I see paintings, diptychs, triptychs, altarpieces and retables. I see all of Painting in shapes and colours, I see all of Sculpture in volumes and textures. In my collection, I indulge and chase my painting obsession, of which I speak but do not practice, exercising its gaze with no experience of it. It is the pursuit of the end goal, the search for a beauty that might not exist but that has a purpose in the perpetuation of its signs.

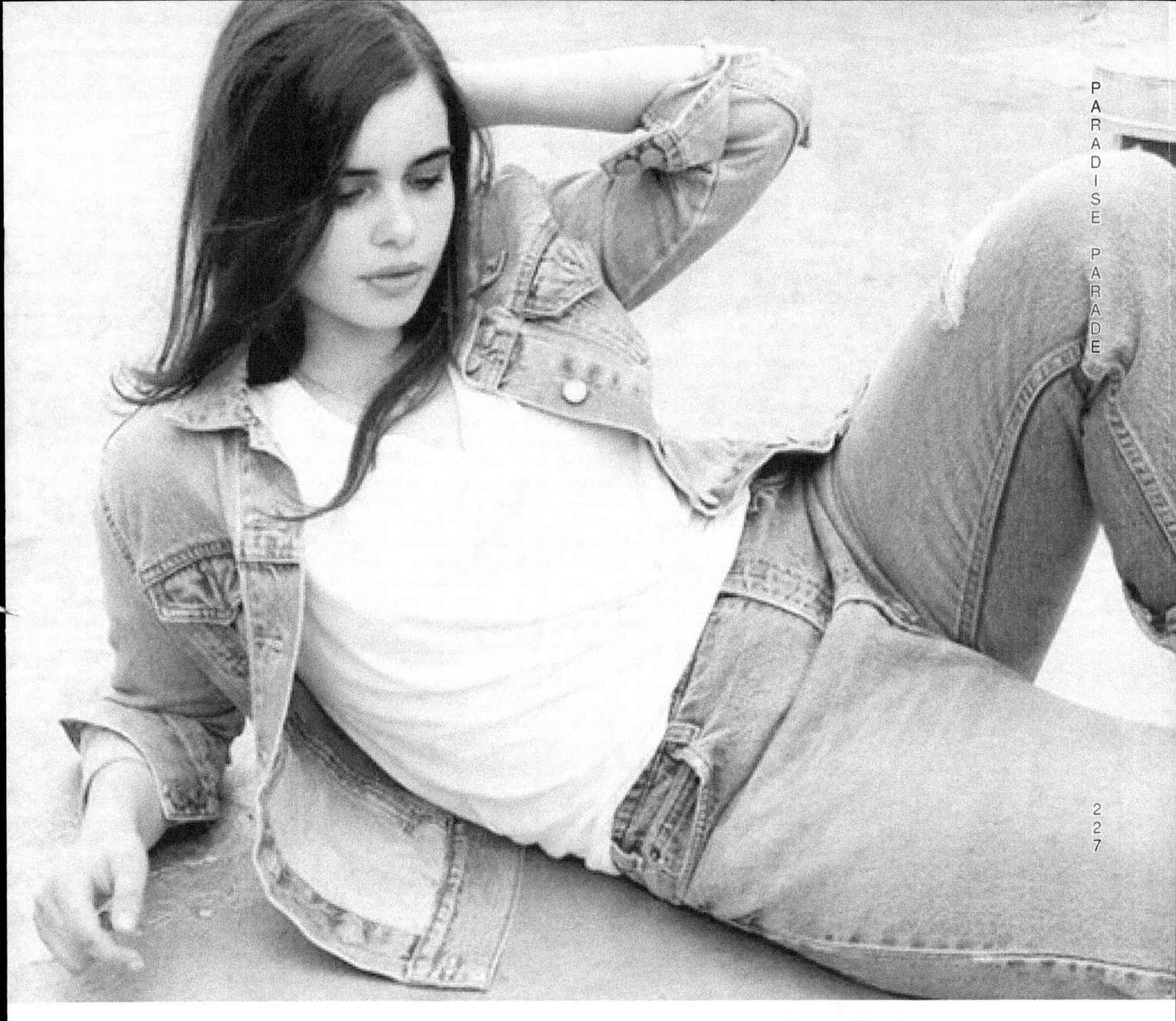

PHOTODUMP

228

IN MY COMPUTER #11

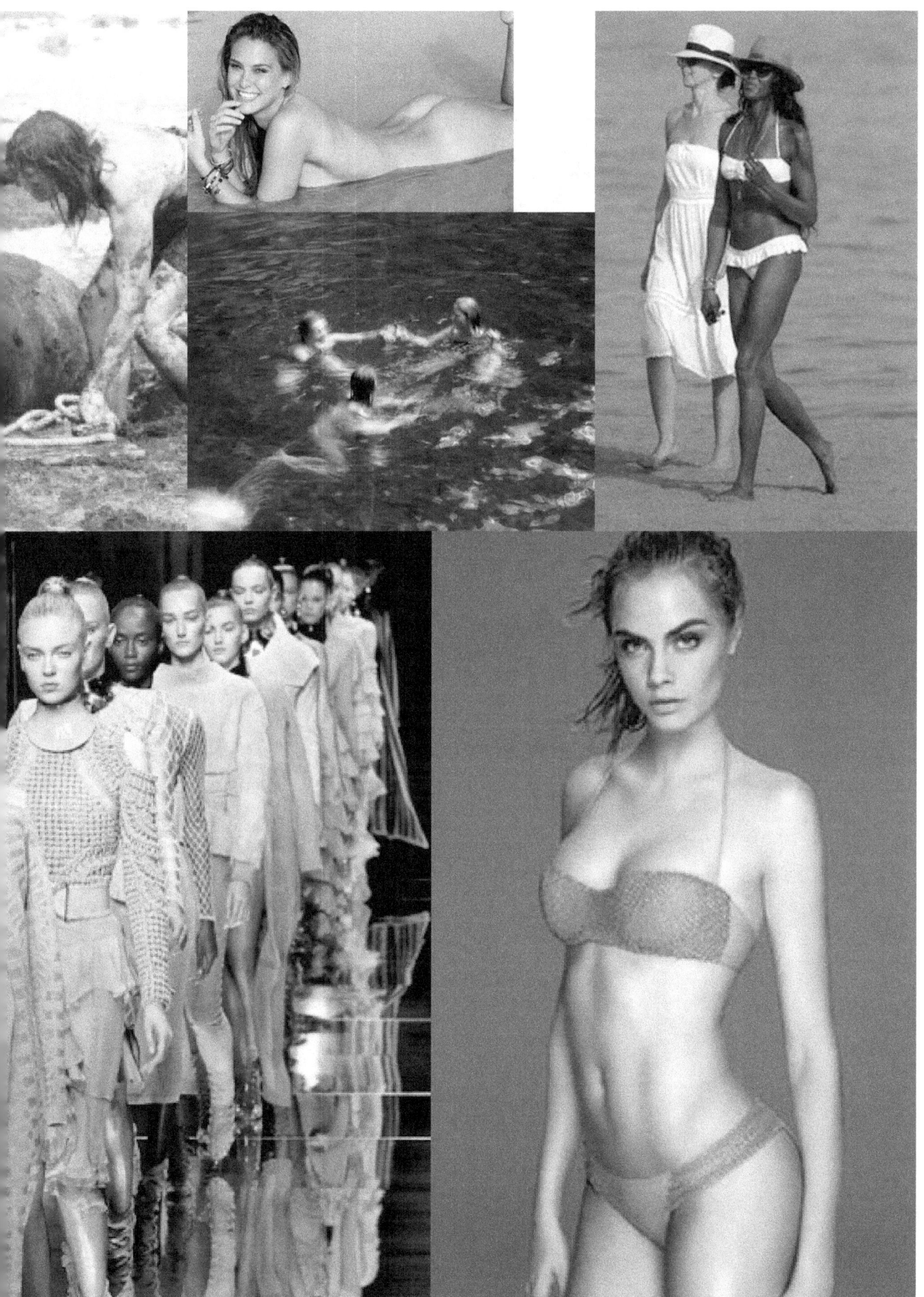

PARADISE PARADE

233

RAVASI

The end

Publisher
LINK Editions — Brescia, 2016
www.linkartcenter.eu

This work is licensed under the Creative Commons
Attribution–NonCommercial–ShareAlike 3.0
Unported License. To view a copy of this license,
visit creativecommons.org/licenses/by-nc-sa/3.0/
or send a letter to Creative Commons:
 171 Second Street, Suite 300,
 San Francisco, California, 94105, USA

Design
Kaspar Hauser
www.ksprhsr.eu

Print and distribution
Lulu.com
www.lulu.com

ISBN 978-1-326-55973-1